Logo Design That Works

Secrets for Successful Logo Design

ROCKPORT

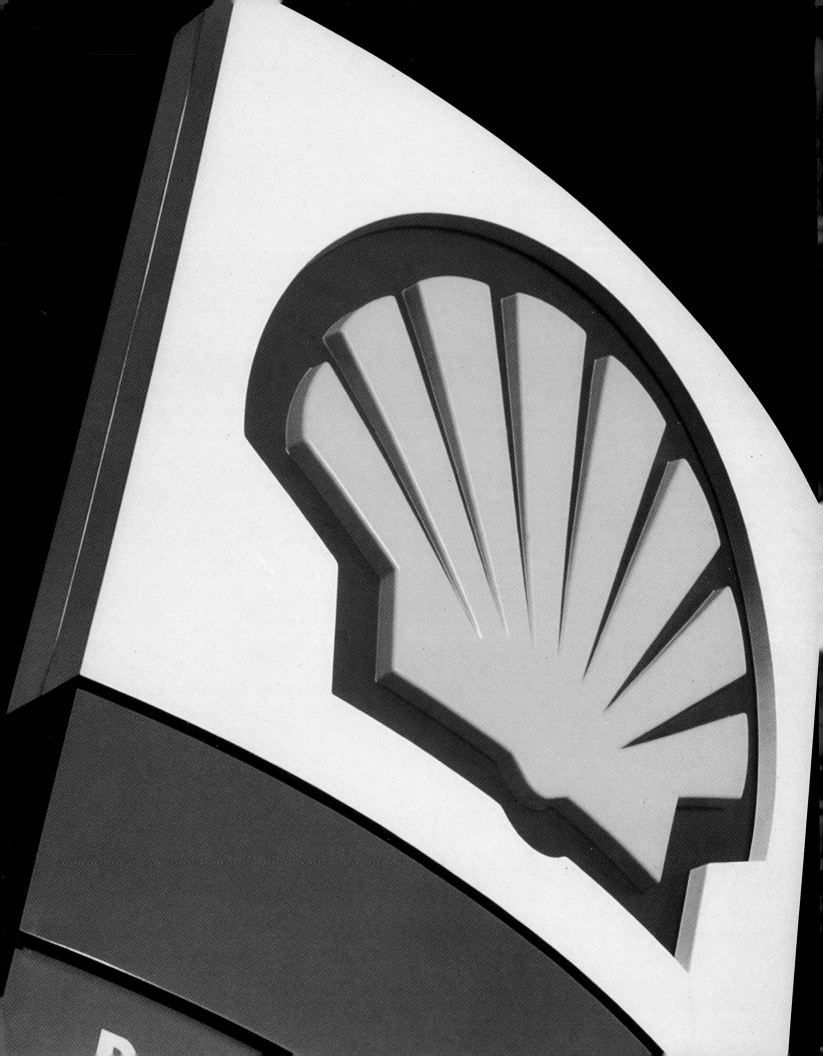

Logo Design That Works

Secrets for Successful Logo Design

GLOUCESTER MASSACHUSETTS

ROCKPORT

PUBLISHERS

Lisa Silver

First published in the United States of America by
Rockport Publishers, Inc.
33 Commercial Street
Gloucester, Massachusetts 01930-5089
Telephone: (978) 282-9590
Facsimile: (978) 283-2742
www.rockpub.com

ISBN 1-56496-759-x

10 9 8 7 6 5

Design: MATTER

Production and Layout: Leslie Haimes

Cover Image: Shell Oil

Printed in China.

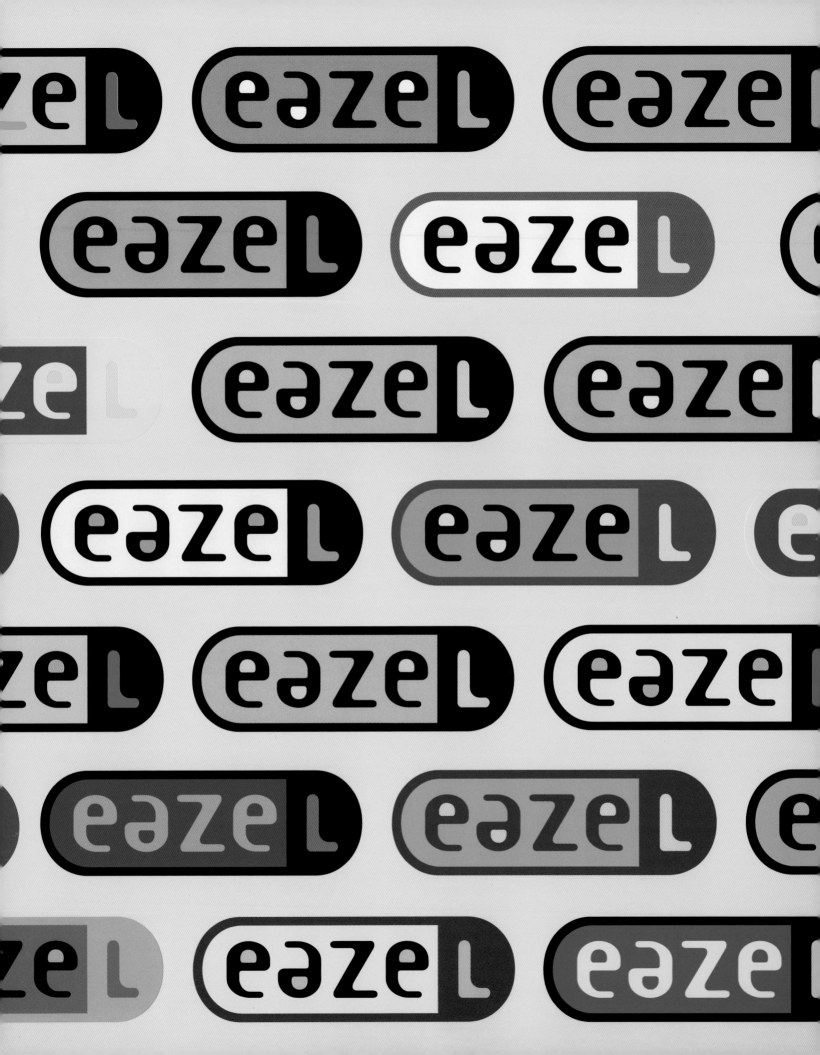

For their help in bringing this book to light, the author would like to thank Jonathan Ambar, Jay Donahue, Kristin Ellison, Francine Hornberger, Kristy Mulkern, Winnie Prentiss, Susan Raymond, Cora Hawks, and Jeff Tycz. Many thanks also go to the contributing designers who despite busy schedules kindly sent materials and provided information about their projects.

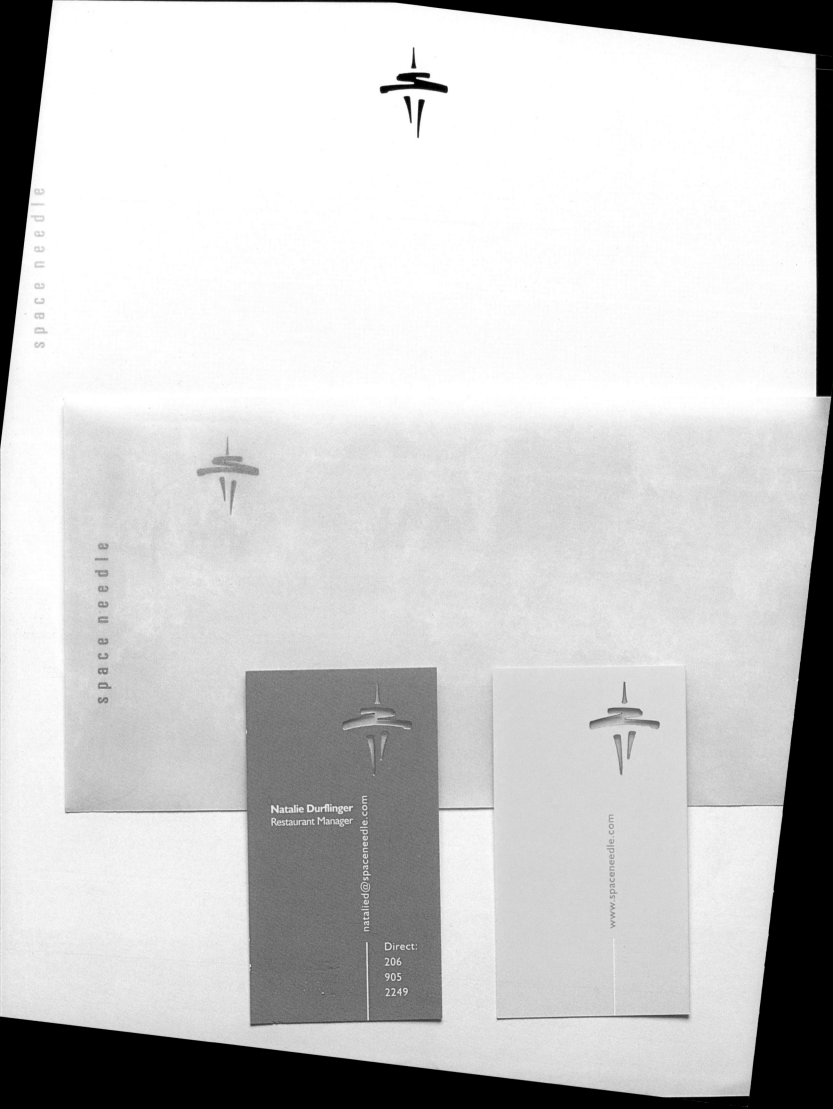

space needle

space needle

Natalie Durflinger
Restaurant Manager

natalied@spaceneedle.com

Direct:
206
905
2249

www.spaceneedle.com

contents

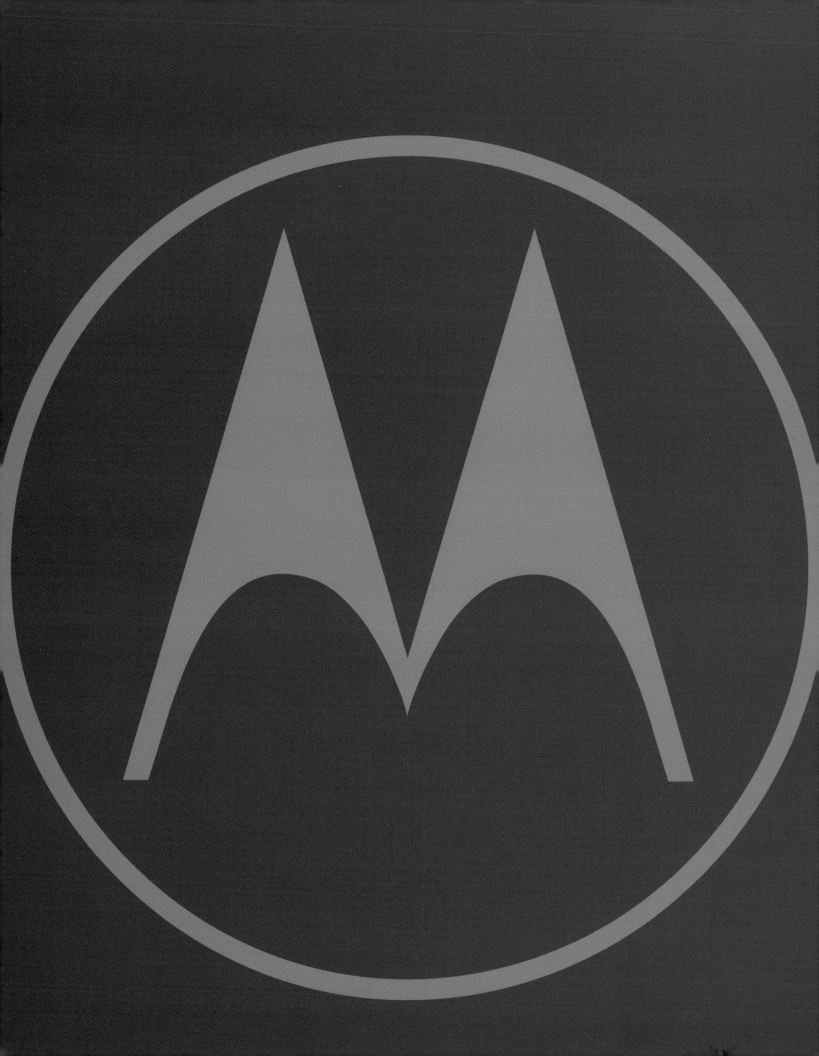

introduction

It is hard to say exactly when logos went from being essential but lackluster business tools to the international graphic design superstars they are today. Was it in the early 1990s when teenagers around the world began tattooing Nike swooshes onto their ankles and arms? Or was it earlier, in the 1970s, when a generation of women took to heart actress Brooke Shields' proclamation "Nothing comes between me and my Calvins" and made logo-imprinted jeans, shirts, and handbags a billion-dollar industry? Or perhaps it was earlier still, with the 1951 debut of the CBS eye, a logo that quickly became so ubiquitous that its own designer, William Golden, dubbed it "a Frankenstein's monster."

Whatever the event that propelled logos to stardom, the fact remains that today's most effective logos do much more than stand for a company, product, or service: They trigger emotion, create desire, even forge communities. (Indeed, how else could one explain the popularity of www.branddating.com, an online dating service that matches people up according to their favorite logos?) Of course, a logo is just one element in a corporate identity system, but it is arguably one of the most important. Unlike business cards, letterhead, or Web pages, elements that can be continually updated to reflect management changes, new business offerings, or shifts in public tastes without much confusion among viewers, the most successful logos are, in the words of the late designer Paul Rand, "like flags." Namely, they are durable, universal, timeless.

And yet, when it comes to their actual design, successful logos are a disparate lot: They might be monograms or pictograms; letters or numbers; circles or squares; animals, plants, suns, stars, or moons. Despite these differences, however, successful logos do share several qualities. For one, they are practical. They work in big sizes and in small, in black-and-white and in color; they translate well across a broad range of media and hold the possibility for animation. For another, they communicate something, whether it be a company description, a business aspiration, or simply an emotion or mood such as elegance or friendliness. And, in the end, effective logos share something else, a quality that is a bit more elusive: as visual forms they offer, in the words of Paul Rand, "sheer pleasure."

Because there is no one answer to the question "What makes a logo work?" this book offers one hundred, in the form of one hundred innovative designs created for a wide range of businesses and services. And though the projects collected in these pages may differ in style and approach, they are all examples of designs that are practical, meaningful and offer, it is hoped, sheer pleasure.

—Lisa Silver

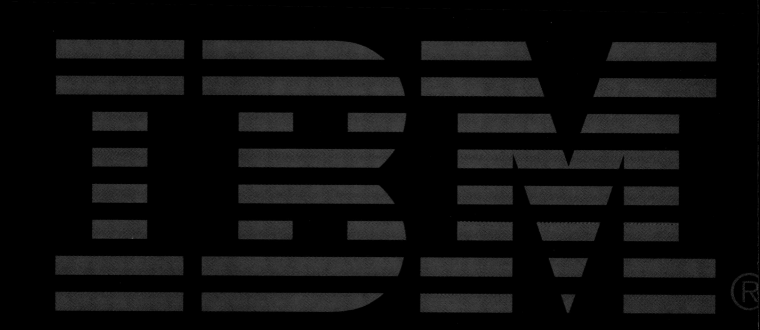

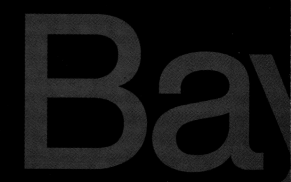

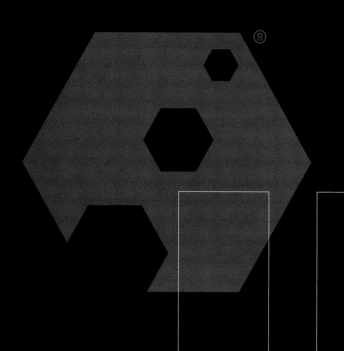

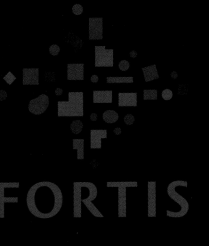

FORTIS

d partners, flexible solutions

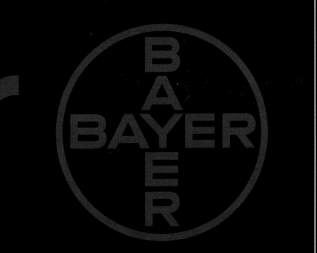

corporate logos

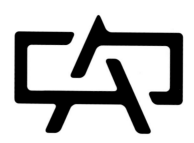

Client

Adams Outdoor Advertising is an Atlanta-based company specializing in billboard advertisements.

CREATIVE DIRECTOR
Kevin Wade

DESIGNER
Martha Graettinger

FIRM
Planet Design Company

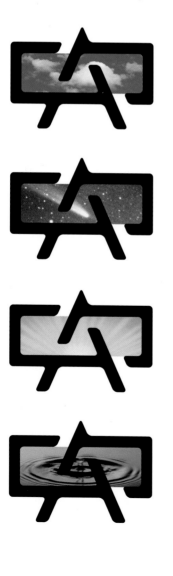

Process

The biggest challenge in developing the logo was finding a way to combat the negative stereotypes surrounding the billboard advertising industry, says Kevin Wade, a principal at the Madison, Wisconsin-based Planet Design. "Billboards tend to be a medium used only after a company has decided to use television, print, or radio advertising," he explains. "Adams wanted to change perceptions, and one way to do that is to develop an identity that is different from the industry norm." And since the norm in the billboard industry has traditionally been nondescript type treatments, Wade's team decided to do the opposite and develop a symbol. The team began by sketching designs based on a capital A, the first letter of the client's name. One direction transformed the A into a monumental object seen from below, an allusion to a billboard viewed from a passing car; another approach flipped the A onto its back, transforming it into a road disappearing into the horizon. From these experiments evolved the idea of an A as an easel displaying a blank canvas, a concept, says Wade, that seemed to lend a kind of "blue sky, anything's possible," quality to the client's product. Pursuing the easel concept, Wade's team refined a design in Illustrator, opting for bold outlines so that the mark would be legible both in very large sizes, as in billboards, and very small, as in business cards. Next, the team searched through stock photography for images to place inside the logo's central rectangle. The four images that were ultimately chosen—a blue sky, a sunrise, a pool of water, and a shooting star—imbue the final mark with an aspirational quality, a message that is further emphasized by the company's tagline: "Out There. Thinking."

What Works

The primary logo, a capital A bisected by a horizontal rectangle, visually references a billboard. The logo's four variations, each of which features a different photographic image in its center, stress the flexibility of billboards as an advertising medium.

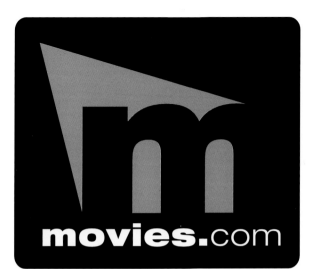

Client

Movies.com is a website that provides information about feature films to a general audience.

DESIGNER
John Smallman

FIRM
Movies.com

Process

Knowing the Movies.com site aimed to reach a wide audience, designer John Smallman set out to create a logo that was general enough to appeal to a range of age groups, cultures, and aesthetic tastes. He began by sketching designs based on film reels, but felt they were too similar to other movie websites. Next, he shifted his focus to the site's tagline, "Don't get left in the dark," and explored different designs based on spotlights. Literal illustrations, however, seemed too cliché to Smallman so he tried a more abstract approach using type. In Illustrator, he created a triangular-shaped spotlight, then placed a reversed-out m at its base. After experimenting with different typefaces, he chose Helvetica Neue Heavy Extended, as its bold, sans serif forms were easily readable within the spotlight shape. He chose a lowercase m because the curved strokes suggest a row of movie theater seats.

What Works

The logo, a lowercase m cut out of a triangular shape, evokes the spotlight created by a film projector shining over a row of seats in a darkened movie theater.

For black and white applications, such as faxes, the logo also comes in a line-drawn version.

Client

AMEC is a multinational engineering and construction group based in Great Britain.

Designer

Matthew Tolliss

Firm

Bamber Forsyth

Process

Updating logos usually means making subtle changes such as streamlining a symbol or choosing a more contemporary typeface. With the AMEC logo, however, a redesign brought a complete overhaul. "The object was to unite a company of many names and parts under one monolithic identity as well as to reflect the business shift away from construction and towards providing engineering solutions," says designer Matthew Tolliss, who led the project. As a starting point, his team isolated three key words to describe the client: speed, simplicity, and transparency, then experimented with ways to visually convey them. Modifying the grid-based design of the old logo wasn't workable according to Tolliss. "We wanted to reflect that AMEC solves complex 3-D problems, and a geometric shape in two dimensions doesn't do that," he explains. "We wanted a symbol that had simplicity, but one that could also be explored and had real depth." The result is a three-dimensional, organic shape with three openings, an abstract form that can be interpreted both literally—as a piece of technical hardware, for example—as well as metaphorically. "The organic shape reflects the fact that AMEC is about people, thinking and solving problems," says Tolliss.

Next, the team altered the logotype, replacing the stern, black capitals of the old identity with a custom, sans serif typeface set in italics to suggest speed and in lowercase letters to convey flexibility. Lastly, the bright orange of the old identity was replaced with blue to suggest a more thoughtful company.

What Works

Whereas AMEC's old logo (below)—which is based on a two-dimensional grid—suggests precision and permanence, the new logo (above)—which features a three-dimensional symbol—evokes agility and openness, two attributes which reflect the client's recent shift away from construction services to engineering solutions.

AMEC's old logo consisted of nine triangles in a grid, a symbol that suggests the form of a modern high rise and a sense of orderly precision.

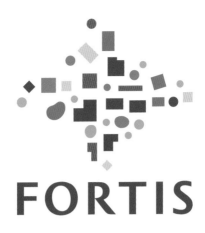

The mark's individual shapes are based on various features of small cities. The squares and rectangles suggest buildings; the green circles, trees; and the blue kidney-shaped oval, a small pool or pond. Two perpendicular lines, formed in the negative space between the shapes, suggest a crossroads where people gather and meet.

Process

Seeking to reflect the common heritage and aspirations of its diverse financial service businesses represented by its brand, Fortis commissioned the London office of Landor Associates to redesign its logo. The aim, says Fortis brand director Cathy Feierstein, was to create a mark that would visually convey the company's focus on the customer as well as the core values of the Fortis brand, namely, caring, innovation, stability and straightforwardness. In addition, says Feierstein, Fortis wanted to create a mark that would stand out from the sea of typical marks used by competing financial institutions. Landor's solution was to focus on Fortis' diverse community of customers, rather than on Fortis itself, as a basis for a design. Using aerial photographs of villages and cities for inspiration, the design team constructed a logo made up of 32 shapes to suggest the buildings, trees and ponds of different communities. For color, the team opted for a primary palette to reflect the client's focus on straightforward, caring customer service. Lastly, the team created a bold, sans serif logotype to balance the more emotional feel of the symbol with a sense of power and stability.

Client

Fortis is a financial service provider with market leadership in the Benelux and niche businesses across Europe, the Far East, and the United States.

FIRM

Landor Associates, UK

What Works

The symbol's form—a collection of 32 vibrantly colored shapes—suggests a grouping where the whole is greater than the sum of the parts, which in turn reflects the diverse communities Fortis serves and seeks to serve. And while the mark's palette, a playful, almost childlike mix of primary colors, exudes friendliness, the custom logotype, composed of bold strokes and stripped of all unnecessary ornament, conveys a sense of gravitas, underscoring the strength of a financial institution whose name means "force" in Latin.

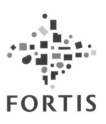

For prestige applications such as signage and flags, the logo comes in a six-color version.

While successful companies tend to grow more complex over time, their trademarks usually become simpler. Such is the case with 3M and its logo.

the evolution of a logo

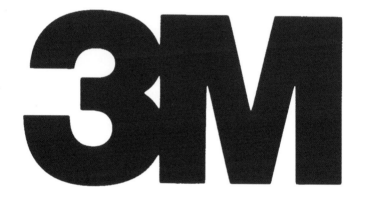

Today:
The mark designed by Siegel & Gale has been used worldwide for nearly a quarter of a century.

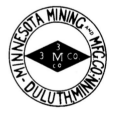 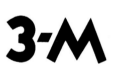 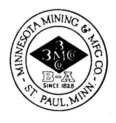

1906:
The first 3M trademark features the company's full name, its location, and, in a diamond at the center, the term "3M Co."

1926:
During the first fifty years of the company's history, trademarks come and go with little fanfare and much variation.

1937:
Traces of the current monogram appear.

1938:
Then they disappear a year later.

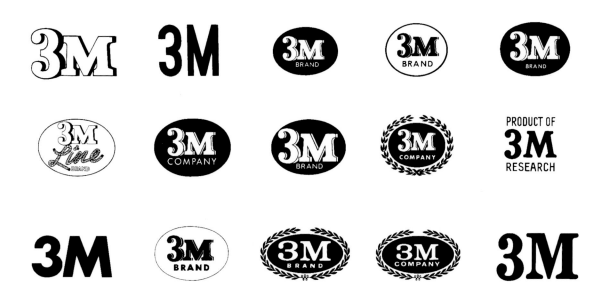

1942-1948:
The monogram reappears, sometimes with a hyphen, sometimes without.

1950:
An oval design debuts. Who created this mark and why is unknown, but soon it is in general use.

1951-1960:
With no standards manual to guide usage, variations of the oval design flourish. In some cases the oval appears as an outline. In others, as a colored solid. Sometimes the oval disappears altogether. When 3M celebrates its fiftieth anniversary, laurel leaves are added.

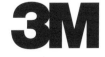

1961:
3M hires the design firm Gerald Stahl & Associates to create a definitive logo that will unite the corporation and all its business units under a single mark. The result is a boxy, serif 3M, whose industrial look earns it the nickname "Plumber's Gothic."

1961:
With the new logo design comes a standards manual that contains four approved variations of the logo. This one is based on the geometric paintings of the Dutch artist Piet Mondrian.

1977:
When variations of the 3M logo multiply due to differing needs of company divisions, the design firm Siegel & Gale embarks on a redesign to solve the problem. The result is a monogram simplified to the bone: Serifs vanish; so do taglines. Even the space between the 3 and the M is stripped away. For color, red is chosen to convey a sense of power.

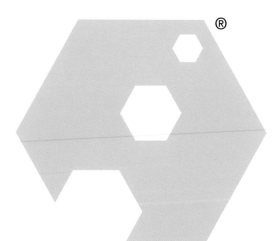

Client

Lightflow is an online company that
provides help in using the Internet.

CREATIVE DIRECTOR
Carlos Segura

DESIGNER
Tnop Wangsillapakun

FIRM
Segura Inc.

Process

From the beginning, the notion of simplicity drove the design process. In part, this
was due to practical reasons, says designer Carlos Segura, who led the project: Since
the mark would be used on the Web, its form had to be streamlined in order to work
well across a range of computer platforms and to allow for the possibility of anima-
tion in the future. Simplicity was also important for conceptual reasons, says Segura,
as it reflected the client's mission of making Web navigation easy. Working within
this parameter, the design team searched for ways to visually represent light and hit
upon a hexagon, a form that carries a range of associations with light—prisms,
sunspots, and camera apertures come to mind—and whose simple geometry easily
adapts to the Web. Next, to suggest the movement of light, three more hexagons,
diminishing in size as they bisect the larger hexagon, were added. For the logotype,
the clean, straightforward Helvetica Neue was chosen; for color, a pale blue to evoke
a sense of calm.

What Works

The logo, a solid hexagon bisected by a diagonal line of three smaller hexagons,
visually represents the process of light flowing through a multifaceted prism, which
in turn reflects the client's mission of "shedding light on," or helping to solve, prob-
lems arising from the Internet.

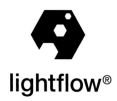

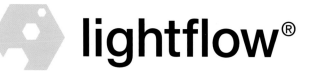

NEW LEAF
PAPER

NEW LEAF
PAPER

Client

New Leaf Paper manufactures and distributes paper
made from recycled material.

ART DIRECTOR

Jennifer Jerde

DESIGNER

Nathan Durrant

FIRM

Elixir Design, Inc.

Process

To reflect its intention of becoming a big player in the paper industry, New Leaf
Paper wanted a logo that felt corporate. And yet, to distinguish itself as being more
environmentally responsible than its competitors, the client also hoped for a logo
that had a natural feel. With these parameters in mind, designer Nathan Durrant
created sketches based on the double meaning of the company's name: "leaf" refers
both to plants and to pages. From these sketches emerged the idea of combining
both meanings into a single image of a turning leaf. But Durrant was not satisfied
with the illustration-based renderings that followed, feeling they were not corporate
enough. So he shifted his attention to photography. He began searching for a leaf
that had clearly visible veins, so that an image of it would be readable at reduced
sizes, and had edges that met at a right angle at the tip so that it could later be
inserted into a rectangle. He eventually chose a hydrangea leaf, photographed it
with a digital camera, then scanned the image into a computer and retouched it in
Photoshop, adding highlights and shadows to create the sense of a curling leaf.
The result is a logo that is at once slick and elegant and, as Durrant puts it,
"enviro-groovy." However, like all photography-based logos, this one does present
challenges in reproduction. To ensure it works well in different sizes and media,
Durrant created a variety of versions, ranging from micro-versions where the leaf
has wider veins and fewer scalloped edges to outline versions for black-and-white
applications.

What Works

The logo, a white rectangle whose upper corner curls downward to reveal a photo of
a leaf, is based on both the client's product and its mission. While the logo's shape
suggests a sheet of paper, and the leaf the paper's recycled content, the mark's
curled edge evokes the phrase "turning over a new leaf," which in this case refers to
switching from non-biodegradable products to environmentally friendly ones.

Perhaps the strongest example of "less is more" is the Bayer cross. Beginning life as an intricate heraldic shield, the logo became instantly recognizable only after its design was pared down to bare essentials.

the evolution of a logo

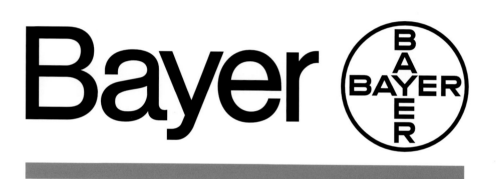

Today:

The Bayer cross has remained virtually unchanged for nearly 75 years.

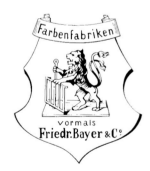

1861:
Bayer's first logo, which depicts a lion and grid, pays tribute to the coat of arms of Elberfeld, the Germany city where the company was founded.

1886:
The logo becomes more intricate. Numerous heraldic elements are added to project a heroic company image.

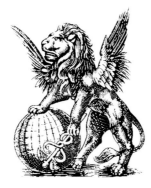

1895:
Bayer introduces a new logo featuring a lion holding a caduceus, the symbol of physicians, and resting one paw on a globe, an indication of the company's self-confident and international intentions. Later, when public taste shifts away from such heroic designs, the Bayer lion is retired.

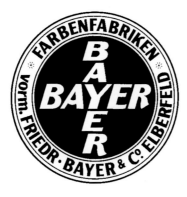

1900:
Hans Schneider, an employee in Bayer's pharmaceutical department, sketches the company's name in a cross-like configuration. Four years later, his design becomes an alternative trademark.

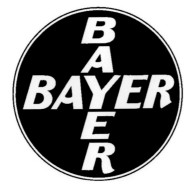

1904:
In the European market the Bayer cross is used with the lion; abroad, the cross is used alone.

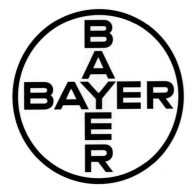

1929:
The Bayer cross is given its present-day appearance. Pared down to bare essentials, the design works equally, stamped on tiny aspirin tablets or lighting up the night sky, as it does in the giant illuminated sign atop the Bayer plant in Leverkusen.

Client

Tech.ridge is a 1000-acre, mixed-use real estate park developed by the Austin-based Gottesman Company.

CREATIVE DIRECTOR
Michael Hicks

ART DIRECTOR/DESIGNER
Jason Godfrey

PROJECT MANAGERS
Sandy Gottesman, Steve Mattingly

FIRM
Hixo, Inc.

Process

Hoping to attract both corporate and residential tenants to the real estate park it was developing in Austin, Texas, The Gottesman Company turned to the design firm Hixo, Inc. for an identity system. The first step, says Michael Hicks, a principal at Hixo, was coming up with a name for the development, one that would distinguish it from the thousands of other industrial parks across America. As a solution, Hicks' team came up with a hybrid name, combining the corporate-sounding "Tech" with the more natural term "Ridge" to form "Tech.Ridge." Next, the team shifted its attention to logos, keeping in mind several design criteria: The logo needed to feel corporate so that it would appeal to potential tenants from the high tech industry; be simple so that it could appear with other company logos without causing visual clutter; and be flexible so that it would be legible in very small sizes to the very large and in applications ranging from printed business cards to fabric signage. To meet these criteria Hicks' team explored type-based marks, eventually choosing to pursue one that mixed a sans serif face with a serif one to form an initialized mark with a hybrid quality to it. "Theoretically, the park is about bringing together different types of businesses and buildings into one area, so that's what we tried to reflect in the mark's design." To echo the non-organic connotations of the word "tech," a modified version of the sleek and modern Futura Bold was used to create the T, while the R, standing for the more organic "ridge" was created out of the friendly Bodoni Book.

What Works

The logo, which is based on Tech.ridge's initials, combines a sans serif T with a serif R to reflect the mixed-use nature of the real estate development: Whereas the bold, streamlined T lends a corporate feel to the mark to appeal to business tenants, the R, with its bulbous, exaggerated serifs, projects a friendly feel to appeal to residential tenants.

In signage, the logo serves as a directional tool, changing colors to indicate different sections of the industrial park. Colors were chosen to match the materials used in the buildings.

 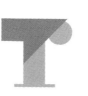 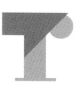 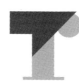

avanadeSM
/systems.solutions.success/from Accenture & Microsoft

Client

Avanade, a joint venture between Accenture and Microsoft, provides technology services to Fortune 500 companies and Internet start-ups.

SENIOR DESIGN DIRECTOR
Gail Taras

SENIOR BRANDING CONSULTANT
Chris Nicklo

DESIGNER
Alessio Krauss

PROJECT MANAGER
Mike Ordoyne

FIRM
Landor Associates, San Francisco

Process

In developing the Avanade brand, a team of designers at Landor's San Francisco office first came up with a "brand driver," a phrase that would sum up the company's core goals and values and be used to guide the design process. The result was the term "depth delivered," a phrase, says Landor's Gail Taras, who served as the project's design director, that reflected the client's mission of providing customers with both expert technical advice and concrete solutions. Then the design team created a name for the newly formed business, eventually selecting "Avanade," a combination of the words "advantage" and "avenue," which evoke a journey towards a goal, and the Italian word ade, which means "help." Next, the team focused on logo explorations. "Everything we did needed to speak to the idea of 'depth delivered,'" says Taras. "We developed a variety of solutions, each of which emphasized a different aspect of the brand driver." One approach, an eye, was meant to evoke insight. Another, a doorway, was intended to suggest a passageway to knowledge. A third, and the one ultimately chosen, was inspired by the "power on" symbol found on computers. Using Illustrator, designer Alessio Krauss flipped the symbol on its side, then created a lowercase a out of it, using bold, rounded lines. A bright orange color gives the final mark a friendly, modern feel.

What Works

The logo, which combines a lowercase a with the international symbol for "Power On," prompts several associations with technology, including power, speed, and the ability to unlock complicated tasks with ease.

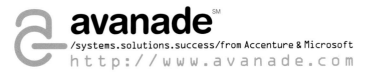

For the Avanade website, designers created a series of icons based on the logo's bold, rounded lines.

While the United logo today is instantly recognizable worldwide, it underwent a number of distinct changes before reaching its present form.

the evolution of a logo

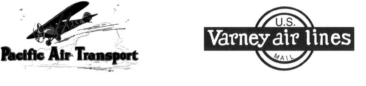

Today:

The present logo

1926-1933:
Each of United's four predecessor companies had its own logo.

When United became the management company for those carriers, it established a bar-and-circle logo with the bar containing the words "United Airlines" and the circle housing each of the four carrier's logos.

1934:
The bar-and-circle logo is modified. The circle now contains a map of the United States inscribed with lines denoting air routes.

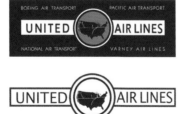

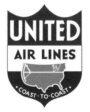

1936:
In an attempt to standardize its logo, the company adopts a red, white, and blue shield.

1934-1940:
With no standards manual to guide usage, logo designs flourish. Each one varies radically from the others.

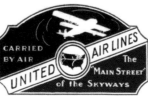

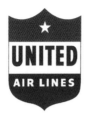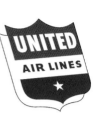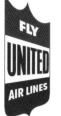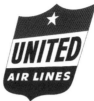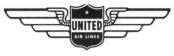

1940s:
Variations of the shield logo appear. In some cases the company's name appears at the top of the shield; in others, centered below a star. In still others, the shield is stretched, slanted, and even sprouts wings.

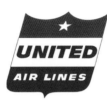

1946-1958:
This slanted version of the shield logo becomes the most commonly and consistently used.

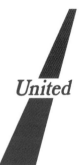

1960s:
Though not an official logo, this slanted spire, created by designer Raymond Loewy, is used on United's aircraft tails and begins to replace the shield. Later, the bold, sans serif typeface used to spell out United's name is replaced by the more delicate Bookman typeface.

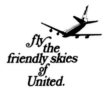

1970:
The shield logo all but disappears. Without a new logo, United's identity becomes tied to its "Fly the friendly skies" slogan.

1973:
United commissions the designer Saul Bass to develop a logo that will convey leadership and innovation in air travel. The result is a stylized red and blue U symbol—later nicknamed "the tulip"—and a custom logotype featuring bold, sans serif letters.

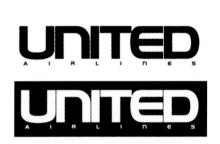

Mid-1980s:
Variations of Saul Bass's design appear. In some cases, the word "airlines" is dropped; in others, letters are squeezed together. Occasionally, the official logotype is scrapped altogether, replaced by the company's name set in Bookman.

1992:
After surveying customers, United determines it needs a more elegant, understated image with international appeal. The design firm CKS Partners retains the U symbol but replaces Saul Bass's sans serif logotype with a more traditional serif face.

1997:
As part of a new branding campaign, Pentagram Design updates the United logo. It introduces new, cropped versions of the U symbol, creates a bolder typeface for the company's name, and drops the word "airlines" from the logotype.

1998:
To distinguish different classes of service within the airline, Pentagram Design develops a new color scheme. Here, the company's name appears in black, while the name of the services appear in gray.

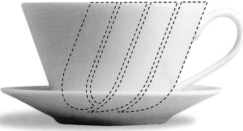

So recognizable has the mark become that the company encourages its designers to incorporate the logo's U shape and 68-degree tilt into everything from navigational buttons on the company website to the shape of the airline's coffee cups.

govWorks

Client

GovWorks is an online portal connecting
local governments and constituents.

DESIGNERS
Carlos Sanchez, Craig Stout

FIRM
St. Aubyn

Process

As an international company that provides a link between local governments and
constituents, GovWorks hoped for a logo that was simple enough so that it could be
translatable across a wide variety of cultures. And yet, as a start up, GovWorks also
hoped for a logo that somehow conveyed the new company's values and goals. With
these two parameters in mind, the design team at the Manhattan-based firm St.
Aubyn began by researching the client to come up with a visual that succinctly
described GovWork's core message. "We found that the message at the heart of the
company was one of passion and idealism, a commitment to a new way of doing
things," says Maria V. Nunes, a partner at St. Aubyn. To visually convey this mes-
sage, the team explored different kinds of imagery in hopes of finding a symbol that
would be recognizable worldwide as representing passion and idealism. The solu-
tion, says Nunes, was the standard bearer. "Whenever a really important human
accomplishment has occurred—whether it be the discovery of new lands or walking
on the moon—it tends to be marked by the planting of a flag," she explains. "So
that's what we sought to translate into a visual identity." Composed in Illustrator, the
mark evolved into a pared-down stick figure holding a flag, a design whose simple
lines ensure easy reproduction across a range of applications. Next, the company's
name was set in a modified Verdana, but the final step, color, presented a bit of a
challenge, says Nunes. "There were a number of colors that we didn't want to go
near," she explains. "A white flag means surrender. The environmental movement
owns a green flag. A red flag, to some people, signifies Communism, while a black
flag recalls a brand of mosquito repellent." The team decided to use orange, a color
that conveys a sense of vibrancy and energy and is not linked to any one particular
country or political movement.

What Works

The logo, a stylized stick figure holding a flag, is meant to symbolize leadership,
unity, and positive change.

classic logo

The CBS eye, the pictographic logo par excellence, suggests both the aperture of a
camera lens and the eye of the TV viewer. Designed by CBS creative director
William Golden and based on the "eye of God" symbols Amish farmers paint on
their barns to ward off evil, the logo first appeared on television on November 16,
1951, as a black-and-white symbol overlaid on a photograph of a cloud-filled sky.
Since then, the logo has become colored and animated, but its basic shape has not
changed in fifty years.

Since first appearing in the early 1900s, the Shell pecten logo has become increasingly stylized, reflecting the trend towards simplicity in graphic design over the past several decades. Today, with its bold shape and distinctive colors, the logo works in any size and in any medium, whether it be a small patch stitched on a serviceman's cap or a mural-sized icon painted on an oil tanker.

the evolution of a logo

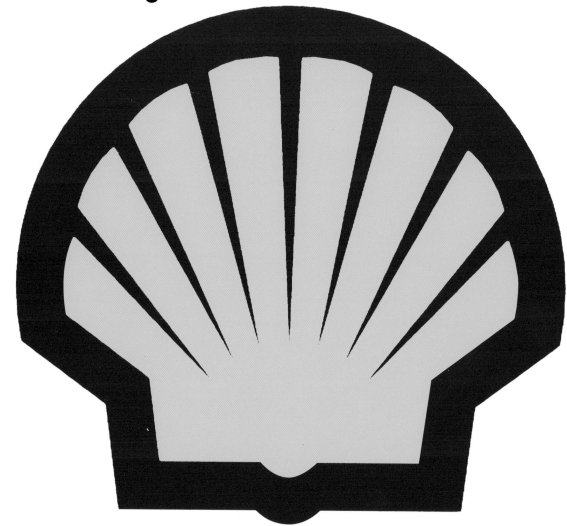

Today

Loewy's 1971 design is used worldwide. The logo has become so recognizable that it often appears without the company's name to identify it.

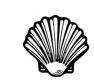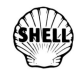

1904:
In the beginning, Shell's logo depicts a realistic rendering of a pecten, or scallop shell. Subtle modeling highlights the shell's ridges.

1915:
The modeling soon disappears making the logo easier to reproduce.

circa 1915:
Color appears when Shell builds its first service stations in California. Red and yellow are bright, which helps Shell stand out, but they are also the colors of Spain, the birthplace of many early Californian settlers. By displaying Spanish colors, Shell hopes to create an emotional bond with customers.

1925:
The word Shell is added to connect the emblem to the company it represents.

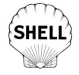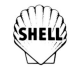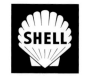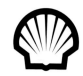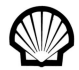

1930:
The shell's ridges all but disappear, making the company's name easier to read.

1951:
In the days before fax machines and the internet, many logos included subtle details such as modeling. Today, this logo would become blurred when faxed.

1963:
Seeds of the present-day logo appear. Single lines efficiently convey the shell's ridges; two triangles describe the shell's base.

1971:
Raymond Loewy, famed for his design of the Coca-Cola bottle, redesigns the logo. He simplifies the shell's scalloped edges into a smooth semi-circle, reduces the shell's ridges from thirteen to seven, and adds a bold, red outline.

1976:
While the company's European divisions adopt Loewy's design, American divisions use a modified version: lines denoting the shell's ridges are thinner; the two outer ridges join at the base.

classic logo

Debuting in 1956 and designed by Paul Rand, the original IBM monogram featured three solid letterforms set in a modified version of City Medium, a geometrically constructed slab-serif typeface created in 1930 by the German designer Georg Trump. In 1962, however, Rand embarked on a redesign, feeling the monogram in solid form exuded an aura of heaviness that didn't reflect the company's progressive aspirations. As a remedy, Rand added stripes to the logo to unify its three letterforms and give it a high-tech feel by evoking the scan lines on video terminals. The mark's simple, flexible style has allowed it to remain virtually unchanged for nearly forty years and to move with ease from print to fax to broadcast to the Web.

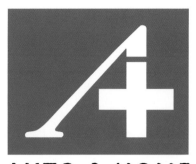

AUTO & HOME INSURANCE PLUS

Process

When California Casualty Group of San Mateo, California, expanded its reach from a regional to a national market, it commissioned the San Francisco-based design firm Broom & Broom to create a new visual identity for its A+ brand. "As an insurer, California Casualty is heavily involved with affiliations such as teacher associations and local highway patrols," explains David Broom, co-principal at Broom & Broom. "So our challenge was to come up with an identity that would work as a stand alone brand, but at the same time remain flexible enough to apply to each one of the client's affiliations." Further, the mark needed to function well in a variety of sizes and media to accommodate the company's extensive business system, says Broom. With these parameters in mind, the design team concentrated on initialized marks, hoping to create one whose distinctive style projected a certain amount of energy. An early approach included a capital A, a plus symbol, and logotype encased within a horizontal bar; another depicted a large A with the word "plus" written out. Out of these emerged the idea to combine an uppercase A and a plus sign into a single mark, an approach that allowed the logotype to be changed depending on which affiliated member was using the mark. "It was a very simple solution in the end. The A in classic serif type reflects the tradition of an established company, while the more modern-looking plus sign gives the mark a kind of contemporary feel," says Broom, adding that a vibrant blue color was chosen to give the mark "a bit of an electric feel."

Client

A+ Auto & Home Insurance provides insurance to associations of public employees.

CREATIVE DIRECTOR
David Broom

DESIGNER
Faye Roels

FIRM
Broom & Broom

What Works

The logo depicts a capital A combined with a plus symbol reversed-out from a blue rectangle. By blending classic and contemporary elements, the mark suggests a company that is traditional yet forward-looking.

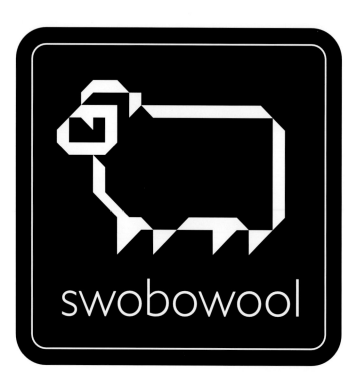

swobowool

Process

When the San Francisco-based Swobo Clothing Company commissioned the designer Woo Andrew Roberts to create a logo for its new line of cycling sportswear, the company was hoping for a mark that would do two things: convey wool as a natural, high-end, technical fabric and appeal to a niche market of young, urban cyclists. "The logo's primary function would be as a rubber patch on the company's wool jerseys," says Roberts, adding that because the mark would also be used in print ads and on the Web, the final design needed to be flexible enough to work in a range of sizes and media. Roberts began by making various sketches of sheep, an instantly recognizable symbol for wool. The goal, he says, was to transform what is usually thought of as a cute, fluffy creature into a sleek, high-performance animal, a depiction that Roberts hoped would reflect the company's use of wool in a high-tech way. The result was an image of a sheep based not on curves and soft edges, but on rectangles, triangles, and straight lines. For the logotype, Roberts chose Gill Sans, a face whose thin, delicate strokes temper the hard-edge look of the symbol. And though Roberts originally designed the logo in black and white "to reflect the simplicity of Swobo's garments," the logo sometimes appears in color when used in various advertising materials.

What Works

The logo, an image of a sheep composed of geometric shapes and contained within a square with rounded corners, is based on the client's product: wool. The mark's simple form allows it to adapt easily to a range of applications, from print to the Web to embroidered clothing labels; while its style, reminiscent of early computer graphics, gives it a slightly retro feel, in order to appeal to the client's target audience of young, urban males many of whom were raised playing computer games like Pac Man and Pong.

Client
Swobo Clothing Company manufactures
and retails cycling sportswear made of wool.

Art Director/Designer
Woo Andrew Roberts

Firm
Woology

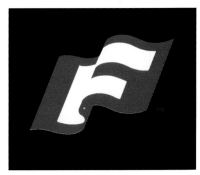

Client

Fisher Companies is a group of milling, broadcasting, and real estate operations.

ART DIRECTORS
Steve Watson, Ray Ueno

DESIGNER
Steve Watson

FIRM
The Leonhardt Group

Process

When Fisher Companies Inc. came to the Seattle-based consultancy The Leonhardt Group, the ninety-year-old company was seeking to unite all of its separate entities—which included flour mills, radio and television stations, and real estate properties—into one company with one corporate identity. In terms of logo design, this meant coming up with a mark that would be flexible in style, to effectively represent all of the company's different entities, and in functionality: the mark needed to work well in a range of sizes and media, from tiny symbols printed on business cards to huge signs painted on building exteriors. To the design team at TLG, the solution was an image of a rippling flag, a symbol that connotes strength, unity, and passion, and whose shape is simple enough to function well in various sizes and media. For the logotype, the team chose Bembo as a base due to its classic, straightforward look and feel. For color, red was selected to project a message of boldness and energy.

What Works

The logo, an image of a rippling, rectangular flag with a reversed-out F at its center, conveys a sense of the power, strength, and unity that is associated with a large corporation with a long history.

Designed to function well in a range of sizes, the Fisher logo has been applied to everything from company flags to business papers.

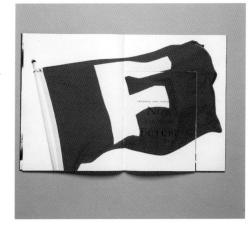

Most logo designs tend to become more simple with time, but that doesn't mean simplicity is always the best solution. In the case of the Prudential logo, a re-design that reduced the well-known rock symbol into a series of stripes was soon abandoned for a more descriptive design.

the evolution of a logo

Today

In 1989, when research finds that many consumers do not recognize the striped rock as Prudential's symbol, the logo is again re-designed. The result is an immediately understandable image of a rock, yet one whose straight lines and simple black-and-white pattern lend it a streamlined, modern feel.

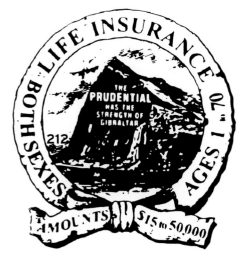

1896:
To project an image of solidity and dependability, Prudential introduces a logo featuring drawings of the Rock of Gibraltar.

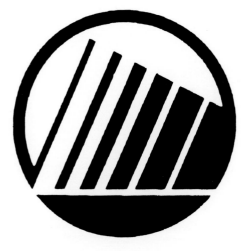

1984:
Like many companies in the 1980s, Prudential embarks on a logo re-design to reflect changes in public taste and boost the mark's functionality when used in the then-new technologies such as fax machines. The result is an extreme abstraction of the Rock of Gibraltar logo.

elegant logos

Process

For art director Sarah Dinnick, the biggest challenge of the project was convincing her clients that a sunflower logo would not work. "They had their hearts set on a sunflower, but I'd seen sunflowers used a zillion times before," she says. "In addition, sunflowers have a seasonal aspect to them. They suggest summer, and the restaurant is open all year round." While Dinnick did create a sunflower logo for her clients, she also developed an alternative approach, which, in the end, the clients happily adopted. Dinnick began by photographing a white plate. (Bought at Ikea, the plate's mass-produced perfection made it "a modern icon and a powerful graphic form," says Dinnick.) Using Photoshop and Illustrator, she next experimented with different typefaces for the logotype, ultimately choosing Trebuchet, a sans serif font that feels modern due to its clean, simple letterforms, but also friendly and warm, owing to the jaunty little upsweeps that end many of the strokes. The colors—warm oranges, reds, and mustards—match the colors of the gallery walls that lead to the restaurant, as well as hint at the colors of the clients' beloved sunflower.

Client

Agora is a restaurant located in the Art Gallery of Ontario.

ART DIRECTOR
Sarah Dinnick

DESIGNER
Samantha Dion

FIRM
Dinnick & Howells

What Works

The logo, a pristine, white plate with the restaurant's name spelled out across it in Trebuchet, is based on the idea of an artist's palette: Just as a palette holds paint, so a plate displays food. The analogy heightens the value of Agora's cuisine as well as links the restaurant to its location in a modern art museum.

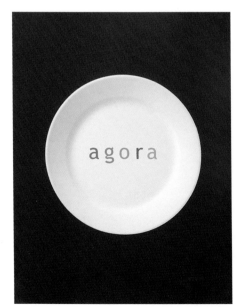

The clean and simple feel of Agora's logo is echoed in the design of the restaurant's menu.

alibris ™

Client

Alibris is an online retailer of hard-to-find books.

ART DIRECTOR
Kit Hinrichs

DESIGNER
Jackie Foshaug

FIRM
Pentagram Design Inc.

Process

Though Alibris is an online company that uses cutting-edge technology to function, the company's actual product, books, is centuries old. This mix of old and new became the starting point for Pentagram's San Francisco office when it set out to design Alibris's logo. "We wanted to create a visual representation that looked modern and fresh but also harkened back to classic book design," says designer Jackie Foshaug. Inspiration came from letterpress books of the 1950s, designs that today feel both modern in that they incorporate simple typography and geometric shapes, as well as old as they were produced in pre-computer days. For the logotype, Foshaug chose Bodoni. "Bodoni is one of those great faces that has roots in history but has a contemporary look because of its square serifs and geometric forms," says Foshaug. Next, she added three overlapping rectangles, elements that echo the color bar forms found in 1950's book design. Unlike the color bars of old, however, a more muted palette of orange, olive, and blue was used to give the mark a more contemporary feel. As a final touch, the first letter of the company's name—libris means book in Latin—was set in italics to aid pronunciation. The italicized a, which resembles the "@" symbol of Internet addresses, also serves as a visual reminder that the company conducts business online.

What Works

The logo, which consists of the company's name set in a modified Bodoni against three translucent, overlapping rectangles, is based on letterpress book design. The rectangles also suggest a stack of books or a series of pages.

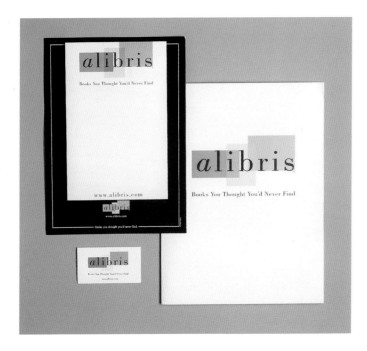

alibris ™

Books You Thought You'd Never Find

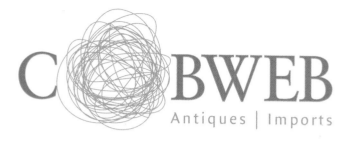

Process

When Cobweb relocated to the tony shopping district of Manhattan's Soho, it wanted a new logo that would appeal to an upscale clientele. The old logo, which featured a drawing of a spider dangling from the company's name, was whimsical and friendly, but did not reflect the store's high-end merchandise, explains Michael McDevitt who was responsible for the redesign. Using the old logo as a jumping off point, McDevitt experimented with designs based on spiders. One promising solution was an eight-legged chair, but McDevitt felt the mark was too specific to one piece of furniture and didn't convey the store's other items. Shifting courses, he focused on the store's recent expansion into Middle Eastern merchandise and created type treatments based on Arabic calligraphy. He soon discarded these as well, deeming them too specific to one country. Next McDevitt focused on spider webs, a symbol that was a literal translation of the store's name but also a form that could be easily abstracted into a stylish mark. Using Illustrator he created a series of weblike designs, pared them down to an elegant, fine-lined scribble, then further refined the result so it could be read as an O. For the final logotype, he chose Bower Bodoni due to its classic, elegant feel, and the colors blue and gold, a combination associated with fine antiques. In printed pieces, the logo's central scribble appears in metallic gold ink; engraved on the store's display window, it appears in gold leaf. "The gold gives the mark a shimmer," says McDevitt, "like a spider's web caught in sunlight."

What Works

The logo consists of the company's name set in Bower Bodoni, with a circular scribble replacing the letter O. While the scribble's form suggests a cobweb, which in turn evokes the past, the scribble's style is clean and abstract, which connects the mark to modern times. This mixture of old and new is in keeping with the client's merchandise: hard-to-find treasures from the past and present.

Client

Cobweb is a retailer specializing in imported furniture and antiques.

Designer

Michael McDevitt

Firm

Designsite

Cobweb Imports, Inc.
440 Lafayette Street
New York, NY 10003

cobwebimports.com
Phone 212 505 1558
Fax 212 505 1730

Process

For designer Buddy Morel the biggest challenge in creating the Kobe Bryant logo was avoiding the cliches often found in sports logos. "All the pro leagues have basically the same idea behind their marks. They're illustrations of a vignette or a pose," says Morel. Hoping to create a distinctive mark, he decided to experiment with type treatments rather than illustrations. One early approach focused on the word "basketball," which conveniently contained Kobe Bryant's initials "KB." Morel highlighted the initials by casting them in different typeface weights and colors, but ultimately discarded this approach. "It didn't provide a symbol that would translate into merchandising and multiple applications," he says. So he shifted concepts, focusing on the client's first name Kobe, which is what fans call the basketball player. While sketching different monograms, Morel noticed that the letter K contained a figure, which, when topped with a circle, suggested a basketball player. Using Franklin Gothic as a starting point, he pulled and stretched the K in Illustrator to achieve a form that would express the bold and energetic playing style of his client. "I was hoping to achieve an interplay between the positive and negative spaces of the shapes," says Morel of the result. "The final version has vectors of negative space impinging on the actual figure of the K, which I think gives a certain dynamic quality to the mark."

What Works

The logo, a bold uppercase K capped with a circle, captures the identity of its subject, a figure caught mid-air with a basketball.

Client

Kobe Bryant is a basketball player with the Los Angeles Lakers.

DESIGNER AND ILLUSTRATOR
Buddy Morel

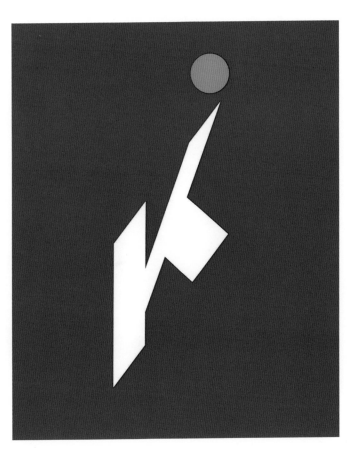

A new logo for a nonprofit group begins with a series of literal illustrations and ends with a sophisticated abstraction.

rough drafts/final drafts

An early approach features stylized fingerprints. Though intended to illustrate GLAAD's impact on society, it also suggested FBI Most Wanted posters and Seger shifted his focus elsewhere.

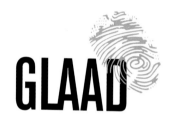

To reflect the client's role as an advocacy organization, Seger created designs featuring pointing hands, but deemed them too strident for a group hoping to build partnerships with media insiders.

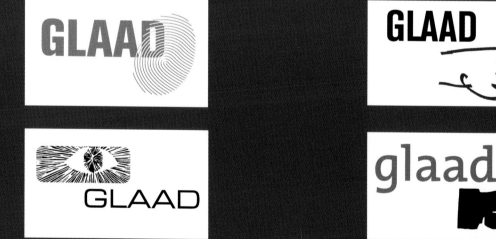

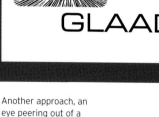

Another approach, an eye peering out of a television set, illustrates GLAAD's role as a media monitor, but Seger felt it wasn't distinctive enough.

Seger altered the logotype. He chose Thesis, a Dutch typeface reminiscent of old typewriter fonts, to suggest the client's role as a media watchdog group, and replaced the stern looking capitals of earlier designs with friendlier lowercase letters.

Client

GLAAD, which stands for Gay & Lesbian Alliance Against Defamation, is a nonprofit organization that promotes fair and accurate representation of gays and lesbians in the media as a means of combating discrimination.

What Works

As a group that analyzes the media, GLAAD knows the power of bold images to attract attention and therefore wanted a logo that was simple. But as a nonprofit organization that values complexity in discussions, GLAAD also hoped for a logo that encouraged multiple interpretations. Both qualities appear in the group's new logo, designed by Sven Seger, which features two rows of circular shapes that gradually merge together and meet at a single point. Though its form is bold and simple to reflect the organization's seriousness of purpose, its meaning is intentionally complex: Does it illustrate a minority group's integration into mainstream life, or does it represent a series of options—ranging from independence to integration—that members of communities can choose from? "Both," says Seger, who wanted to leave space in the design for the viewer to decide. "Within GLAAD there are some people who want integration into mainstream American life and others who want to maintain separation. That's why we went with this particular direction. It causes discussion and that's what GLAAD is all about."

STRATEGY

Ron Capello

CREATIVE DIRECTOR AND DESIGNER

Sven Seger

FIRM

Enterprise IG

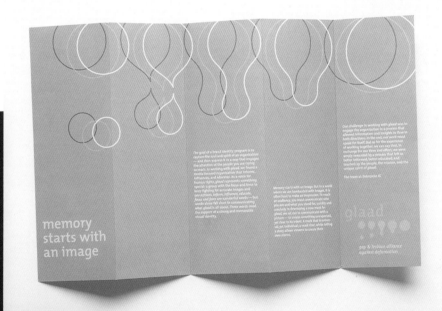

The final Logo
The abstract form represents GLAAD's focus on change.

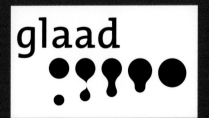

Unsatisfied with literal illustrations, Seger turned to abstraction in hopes of creating a design that evoked GLAAD's focus on change. Experiments with photograms, created by dropping different fluids onto photographic paper in a darkroom, lead to a logo of fluid-like forms.

Since GLAAD lacks the budget for four-color printing, Seger limited the color palette to two colors. "Mixed together, yellow and gray allows for a whole range of different, almost earthy, beige tones," says Seger of his choice. This two-color brochure illustrates this point.

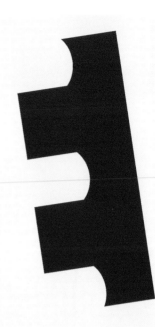

Client

The End is a production company that specializes in television commercials, music videos, and feature films.

DESIGNER

Buddy Morel

Process

The project began with the client requesting a logo that looked fresh and current, yet gave the impression of belonging to a long-established company. To designer Buddy Morel that meant creating a mark whose visual power lay in its simplicity. As a starting point, he asked the client for a roll of 35-millimeter film, then made sketches based on it. "I played with it for about a month, doing everything you can imagine to it," says Morel, who adds, "all of it was junk." So he started over, this time with a pair of scissors rather than a pencil. "I started cutting the piece of film into little pieces," he says. "I was pretty much winging it. I didn't pre-visualize the concept." The pieces he cut were tiny—less than a quarter of an inch long—but when Morel laid them out on a piece of paper, he noticed that one contained a crude E, created by the negative space between two film sprockets. After scanning the film piece into a computer, he used Illustrator to modify the form, making the E more legible, while at the same time making sure the solid form still read as a piece of film. Next, he added a slight tilt to the mark's orientation, to create a spontaneous feel and suggest a snippet of film strewn on a cutting room floor. The result is a logo that serves both as an illustration of the company's services, as well as a monogram that refers to the company's name.

What Works

The logo presents a visual puzzle to the viewer. While the colored form reads as a snippet of film, which refers to the type of service the client provides, the negative space surrounding the form reads as an E, the first letter of the company's name.

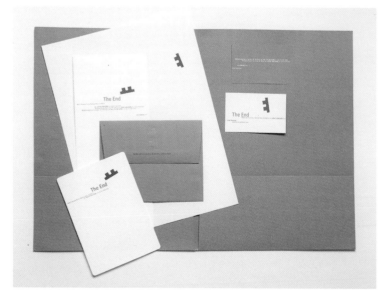

Client

The American Sommelier Association is a nonprofit
organization for wine experts.

Art Director/Designer

Jon Rohrer

Firm

Flux Labs

Process

In developing a logo for the American Sommelier Association, designer Jon Rohrer
hoped to create a mark that instantly communicated the idea of wine and had a
classic, almost old-fashioned feel to it. An idea came almost instantly. Using
Illustrator, he experimented with a capital A, the first letter of the client's name,
replaced its cross bar with a corkscrew, then selected the typeface Adobe Garamond
for its elegant, sophisticated feel. Next, he experimented with logotypes. "I didn't
want to just center the client's name under the symbol because that seemed too
trite," he says. Instead, he created what amounts to a secondary logo: the client's
name set in a configuration reminiscent of a label, with the word Sommelier in the
center, and the words American and Association laid out in arcs above and below it.
For color, Rohrer chose a burgundy to suggest the color of wine.

What Works

The logo features a capital A set in Adobe Garamond. The cross bar has been
replaced with a corkscrew, which reinforces the subject's identity as an organization
for wine experts.

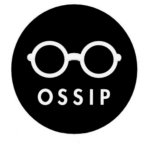

Client

Ossip is an eyeglass store that specializes in high-end eyeglass frames.

Designer

Eric Kass

Firm

Lodge Design

Process

When the Indianapolis-based Ossip came to Lodge Design, the optometry was looking to create a series of print ads. What Lodge Design saw however was a need for a redesigned logo as well. The existing logo—a pair of glasses above a rectangle that contained the name "Ossip" set in a serif face—came with a certain amount of equity in that the company had been using a version of it for nearly 50 years, but the serif face felt old-fashioned, says Eric Kass, the principal of Lodge Design, and the mark's configuration needed tightening up so that it would pop out when used in ads and signage. Kass began by replacing the serif face with Futura Heavy, a typeface whose simple letterforms allow the mark to work well in a range of different sizes and media and whose bold strokes lend an eye-chart feel to the mark. Next, he enclosed the glasses and logotype within a circle to streamline its form and to suggest a human face.

What Works

The logo, a circle containing a pair of glasses and the company's name set in Futura Heavy, illustrates the product being sold and conveys a sense of friendliness due to its similarity to a human face.

Process

When the founder of a new commercial real estate firm came to Lodge Design for a corporate identity, he was hoping for something that would appeal to an upscale clientele. "As a realtor, the client specializes in bringing high-end restaurants and retail chains to downtown Indianapolis," explains Lodge Design's Eric Kass, "so we thought this was a good opportunity to create an identity with a softer, more fashionable feel than the usual industrial, down-and-dirty type logos you find in the real estate industry." The first step was coming up with a name. "The client originally wanted to name the company after himself, but we recommended creating something that was more descriptive, something that gave a personality to the company," says Kass. The result was UrbanSpace, a name that not only suggests what kind of business the client is engaged in, but lends a touch of cachet due to the use of the word "space" rather than the more banal "lots" or "properties." Next, Kass's team turned to logos, focusing on skyline imagery. "We didn't want to create a literal skyline, but rather one that was somewhat musical and bouncy so that it would reflect the motion and excitement of the city," explains Kass. The result was a series of five rectangular solids of varying sizes placed in a staggered alignment above the company's name. For typography, a mixture of the sans serif Futura and the serif Clarindon was selected both for practical reasons—the two faces separate the name making it more readable, says Kass—and for aesthetic ones: "One face is modern and the other is less modern, which reflects the architecture of downtown Indianapolis." For color, Kass deliberately avoided the bold primary colors found in most real estate logos, choosing instead a muted green, brown, and blue. "We didn't feel the logo had to scream to be effective," he says.

Client

UrbanSpace is an Indianapolis-based real estate firm that specializes in high-end commercial properties and office space.

DESIGNER
Eric Kass

WRITER
Jason Roemer

FIRM
Lodge Design

What Works

The logo, which consists of five rectangular solids above the company's name set in Futura and Clarindon, echoes the urban environment where the client conducts business. While the logo's colored forms evoke a city skyline, the logotype, a mixture of sans serif and serif typefaces, is meant to suggest the mingling of old and new that characterizes modern cities.

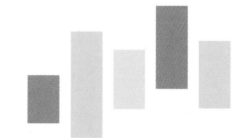

URBAN SPACE

rough drafts/final drafts

As a starting point, designer Philip Kelly turned to the client's writings about termite mounds. Though blind, groups of termites are able to build two separate structures that are virtually identical to one another by releasing chemicals called pheromones that serve as a form of communication. The client used this three-dimensional model, which shows the pheromone activity between two termite mounds, as a basis for her design of an African spa. Kelly, in turn, used it as a basis for the client's logo.

Kelly created sketches for a logotype based on a plan view of the three-dimensional diagram of termite pheromone activity.

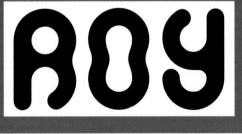

After filling in the letter-forms, Kelly deemed the result too fluid for a mark representing an architect.

Client

Lindy Roy is an architect and critic best known for her design of an environmentally friendly spa in Botswana, which was inspired by the structure of termite mounds.

What Works

The logo features the client's last name set in Trade Gothic, which has been modified so that the last letter, a Y, is an upside down version of the first, an R. As a result, the mark becomes a visual demonstration of symmetry, a basic principle in the client's field of architecture.

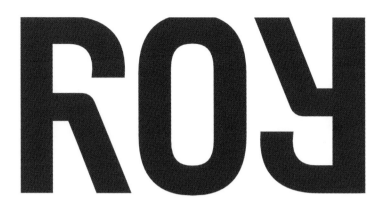

DESIGNER

Philip Kelly

FIRM

pk(des)gn

Next, Kelly experimented with Trade Gothic, a typeface whose strong, sans serif strokes echo architectural forms. He noticed that when the R is turned upside down, it resembles a Y.

The final Logo

Because the client's offices are located in Manhattan's meat packing district, Kelly chose a color—a burnished red—that suggests dried blood, and used French Paper's Butcher Paper stock for the stationery system.

SPINNER
.com

Client
Spinner.com is an online company that provides down-loadable music for use on personal computers.

Art Director
Gaby Brink

Designer
Paul Howalt

Firm
Howalt Design

Process
As a new company entering the competitive field of downloadable music, Spinner.com hoped for a logo that was eye-catching to appeal to a young audience, yet classic so that it would not require constant updating. Using the client's name as a starting point, designer Paul Howalt experimented with different ways of visually representing spinning records. Preliminary designs included spiral- and organically shaped symbols, but these were ultimately abandoned when Howalt found them too difficult to read once the logotype was added. Next, he explored type treatments, hoping to find a way to use type to convey the same spinning motion he had created with the earlier symbols. Searching through typefaces for one that was geometric and condensed so that it could be rotated and warped and still remain legible, he ultimately chose Venus Bold Condensed. He then manipulated the font's letters so they would appear circumscribed within an invisible circle, then added a radial blur to the letters in Photoshop to create the illusion that the letters were spinning. The resulting mark is distinctive enough to stand out among competing music sites while at the same time simple enough to function well in a Web environment.

What Works
The logo is composed of the company's name set in a modified Venus Bold Condensed. The curved letterforms and blurred motion streaks suggest the spinning of a DJ's turntable.

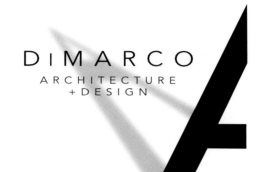

Client

DiMarco Architecture and Design is a Seattle-based firm that specializes in residential work.

Designer

John Smallman

Process

To reflect the client's modern designs for homes and businesses, designer John Smallman hoped to create a mark that felt light and airy. Preliminary sketches included geometric forms, which echoed the architectural details found in the client's studio, and drafting tools such as a compass. Neither approach completely satisfied Smallman, who deemed the results too generic. As he continued to experiment with the placement and arrangement of forms, he noticed that one of his drawing tools, a plastic 45-degree triangle, cast a shadow on his drawing paper that looked like an A, the first letter in the word architecture. Inspired, he replicated the shadow in Photoshop, then added it to a solid A in Illustrator. Next, he sliced the solid A in half so that it would be read not only as a letter, but also as a geometric form. For the logotype, he chose Avenir Book, a typeface whose simple forms complement the basic geometry of the mark, and chose a palette of black, white, and gray, feeling that color would detract from the mark's focus on form and light.

What Works

The logo, which features a solid, half-A shape in the foreground and a shadowed full-A shape behind it, refers to the interplay of light, shape, and form found in architecture. The half-A shape invites multiple readings. Viewed as a letter, it stands for architecture. Viewed as a geometric form, it suggests a structural element, such as a support beam.

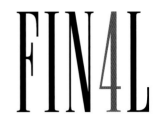

Client

When the Phoenix-based real estate company
Del Webb Corporation set out to find a national
ad agency, it dubbed the search "Final 4,"
a phrase borrowed from sports tournaments.

ART DIRECTOR/DESIGNER
Neill Fox

FIRM
Young Associates

Process

In choosing the name "Final 4" for its nationwide search for an ad agency,
Del Webb Corporation hoped to connect its efforts with the basketball play-offs
that were taking place at the time. When art director Neill Fox set off to create the
campaign's logo, however, he decided to avoid all sports imagery. "I didn't want it to
look like a basketball logo," he says. "I wanted the logo to be a little more corporate
than that, because searching for an ad agency is not a game. It's a serious proposi-
tion." Fox therefore avoided imagery such as basketballs and tournament ladders—
symbols suggested by the client, but which Fox felt were too "trite"—and concen-
trated on type treatments instead. His solution, created in Illustrator, is a visual pun
that carries with it a sense of play, but whose elongated, serif letterforms give the
mark an elegant feel. To reinforce the mark's formal feel, he chose the straightfor-
ward colors black and red.

What Works

Set in the typeface Ultra Condensed, the logo features the word Final with a 4
replacing the A. As a visual pun, the logo communicates a sense of playfulness to
appeal to an audience of ad agency creatives. And yet the humor is tempered by the
mark's elegant typeface to reflect the seriousness with which the client viewed its
search for an ad agency.

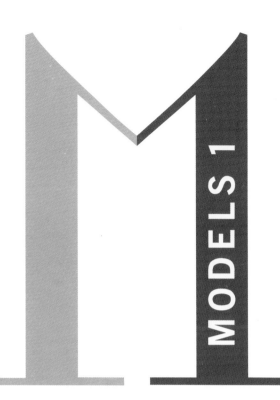

Client

Models 1 is a modeling agency based in London.

DESIGN DIRECTOR
Nina Jenkins

PROJECT DIRECTOR
Jules Anderson

DESIGNERS
Rob Howsam, Tony de Ste Croix, Annabel Clements

TYPOGRAPHER
Angela Hughes

FIRM
The Partners

Process

Hoping to build recognition for its brand and extend it into a line of fashion and beauty accessories in the future, Models 1 turned to the London-based design firm The Partners for a new identity. "Our brief was to create a distinctive, elegant, timeless, and premium visual identity," says Nina Jenkins, the design director for the project. "The identity needed to be appealing to all ages of models, reassuring to parents of young models, and memorable to clients." The design team began by concentrating on the client's core values and personality. "Models 1 is known for its integrity," Jenkins explains. "It is a stable, reliable, solid agency in the frenetic and chameleon-like world of fashion." From these attributes arose "a general theme of yin and yang, one of balance, poise and tranquility," says Jenkins. To visually convey this theme, the team explored different configurations of a capital M, the first letter of the client's name, alongside reflections. From these sketches evolved the idea of creating an M out of two 1s, an approach that combined both the client's name and reflections into one streamlined mark. The team then refined the design, elongating the M's legs to reflect the grace associated with fashion models and lengthening the serifs at the M's base to suggest stability. Next, the team added a logotype, set in a custom sans serif face, to the M's leg. For color, two tones of metallic silver were selected, evoking the mirrors associated with the fashion industry as well as a general sense of elegance.

What Works

The logo features a capital M constructed out of two numeral ones. While the mark's slender, elongated form calls to mind the height and grace associated with fashion models, the configuration of the two ones—one mirroring the other—evokes balance and harmony, an apt message for a company specializing in beauty and fashion.

The final National Campaign Against Youth Violence logo began as an afterthought. Five minutes before faxing seven other ideas to art direct or Joel Templin, designer Felix Sockwell thought of one more: combining a dove with a hand. His last-minute scribble evolved into the final design.

rough drafts/final drafts

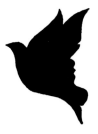

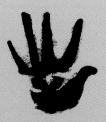

Searching for a concept, designer Felix Sockwell sketched several possible directions, including designs that use doves to symbolize peace, a hand to communicate "stop violence," faces to represent families, and stars and stripes to reflect the campaign's national aspect.

Flipping through an old clip-art book, Sockwell came across a dove created in the 1950s by Eugene Grossman for the Mitsubishi Bank Group. Sockwell sketched a logo design based on it.

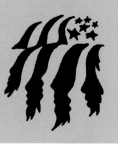

Client

The National Campaign Against Youth Violence (NCAYV) is a White House initiative whose aim is to educate parents about teenage violence.

What Works

The urgent nature of the anti-violence campaign is suggested in the logo through two bold images: a dove and an upraised to hand, reversed-out of two rectangular shapes in red and black. Designed to look as if it were hastily cut out of paper, the logo recalls the visual power of protest posters from the 1950s and 1960s.

AGENCY
Foote Cone & Belding

DESIGNER
Felix Sockwell

ILLUSTRATORS
Felix Sockwell, Erik Johnson

FIRM
Templin Brink Design

The final Logo
For color, black and red are selected to convey a sense of urgency.

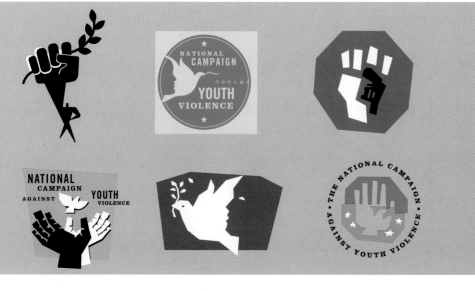

Rough sketches are fleshed out and refined in Illustrator. Sockwell later feels the designs incorporating guns are too negative. And though he likes the design that features a blue circle with silhouettes of a face and dove "for its 1950's, Boy Scout-y feel," he prefers the boldness of the hand-dove approach.

Client

Oxygen Media is a multimedia company specializing in television shows and websites aimed at women.

In these frames from an animated sequence, a series of circles move across the screen, slowly revealing the logo.

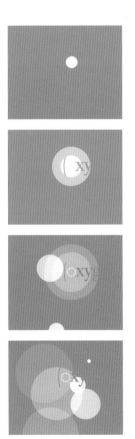

Process

In developing the Oxygen identity, the Massachusetts-based firm Hatmaker worked within several design parameters. For one, the logo needed to work across a broad range of media, including television, the Web, and print. For another, the logo's style needed to suggest a company that was fresh, upbeat, and modern. To meet the first criterion, designer Haig Bredrossian, who, with the late Tom Corey, led the project, ruled out illustration-based approaches. "Anything that is too intricate or complicated doesn't lend itself to animation, and video applications were a big consideration for this project," he explains. And though the client's name offered the possibility for a symbol-based logo—one incorporating the scientific abbreviation for oxygen, "O2," for example—Bredrossian ruled out symbols as well, believing a new company needed to display its full name to build recognition. Instead Bredrossian explored type treatments, hoping to come up with "something that had never been seen before," he says. To this end, he hit upon the idea of creating a logo that, like oxygen itself, was "invisible." To accomplish this, he decided that the final logo would have no set color but instead change continually to match whatever background it was placed against. The logo would only become visible when an image—a photo of a person, for example, or graphical elements like circles or squares—passed between the logo and background.

To create the mark, he experimented with different typefaces, ultimately choosing Bodoni Book for its light, airy feel. He then replaced the letter O with a custom circle, intending it to serve as a starting point for animated sequences or as a navigational button for web applications. Lastly, he added a playful twist to the mark by placing it within parentheses, the joke being that while parentheses are used to signify nonessential material, here they contain the very stuff humans need to survive.

The resulting mark, says Bredrossian, "is a very unconventional logo. It can't merely be placed into an application, but requires a lot of thought and care to reveal its potential. And in my mind that's what makes it memorable."

What Works

Like the gas the client takes its name from, the logo is designed to be invisible. Its form—the word "oxygen" contained within parentheses—is revealed only when something passes between it and the background.

DESIGNER
Haig Bedrossian

COMPANY CREATIVE DIRECTOR
Tom Corey

FIRM
Hatmaker
COURTESY OF
Oxygen Media, LLC

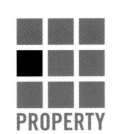

PROPERTY

Client
Property is a Manhattan-based store specializing in modern furniture and home accessories.

ART DIRECTOR
Giovanni C. Russo

DESIGNER
Carrie Hunt

FIRM
No. 11, Inc.

Process
To reflect the spare aesthetic of the furniture it sells, the client wanted a logo that was modern but not trendy. To designers Giovanni C. Russo and Carrie Hunt that meant coming up with a design based on geometric shapes, elements that characterize the modern design movement. Preliminary sketches featured a single square, a shape chosen both for its simplicity as a graphic element and for the way it visually conveyed the client's name. More squares were then added, resulting in a design that suggested building blocks, a visual metaphor for the design process. Next, the design team experimented with different configurations of the blocks, lining them up in a horizontal row, fitting one within the other, and placing them in a grid. It was this last approach that was deemed the strongest as it encouraged multiple readings: the mark could be read as a series of building blocks or as a city block or as a facade of an urban high rise—all associations having to do with modernism. Further refinement led to the darkening of one of the squares within the grid to create a sense that Property as a store is out of the ordinary. For the logotype, new, trendy fonts were avoided in favor of Trade Gothic, a typeface whose clear forms and slightly blocky feel fits well with the grid-based symbol. For the palette, chartreuse-greens were selected to give the mark what Hunt calls "an old-school quality" that mirrors the style of the client's merchandise.

What Works
The logo, a grid of nine squares—one of which is darker than the others—prompts several associations with modernist design: the grid echoes modernism's spare aesthetic, while the individual squares suggest building blocks that can be arranged and rearranged into different formations, much as geometric forms are configured and reconfigured to create different pieces of furniture. The mark also suggests a city block where one property stands out from its neighbors.

PROPERTY

14 WOOSTER STREET NEW YORK NEW YORK 10013
TELEPHONE 917 237 0123 FAX 917 237 0124

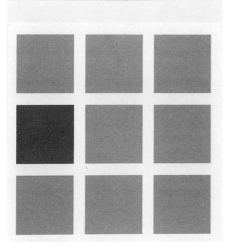

THE **PROJECT**

THE **PROJECT**

THE **PROJECT**

Client
The Project is a Manhattan-based gallery specializing in contemporary art.

Designer
Wendy Wen

Process

In developing what would become The Project logo, Manhattan-based designer Wendy Wen hoped to create a mark that was both forward-looking, to reflect the cutting-edge art shown by the client, and understated, so that when the logo was applied to gallery announcements or magazine ads, it would not overpower the gallery's art. With these parameters in mind, Wen explored type treatments, eventually selecting Akzidenz Grotesk as a face for its simple, unadorned letterforms. Next, she added a twist to the logotype by replacing the letter O with what she calls "changeable blips," a series of circular icons that would represent the different types of art shown at The Project. In Quark, she created one circle out of hand-drawn scribbles to represent painting; another composed of two arcs to suggest architecture. For sculpture, she opted for a solid sphere; for photography and video, a camera lens; and for performance art, two blurred circular forms that suggest motion. Further refinement led her to choose a bright, vibrant red for the icons, a color that is tempered by the soft, blue-gray she chose for the rest of the logotype. The resulting mark functions much like a modern, white-walled gallery: Its simple aesthetic allows for infinite variations while maintaining a consistent visual identity at its core.

What Works

The logo is composed of the client's name, set in Akzidenz Grotesk, and a set of six circular icons. Used to replace the letter O in the logotype, the icons change depending on the type of art The Project is showing.

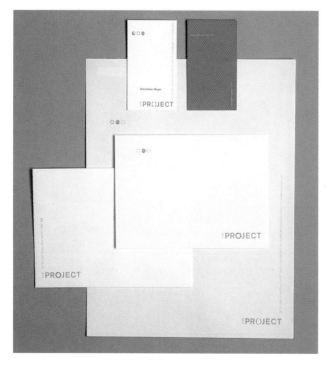

Client

Milk Studios is a 50,000-square-foot photo and special events studio in Manhattan.

Process

From the beginning, designers at Base wanted to avoid any symbol or mark that referred to milk as a drink. "That would have been too obvious," explains Geoffrey Cook, managing director of Base. Instead, to appeal to the photographers and fashion designers who use the studio, the Base team focused on the studio's amenities, the number one being lots of space: a valuable commodity in space-starved Manhattan. The team began by translating the studio's architecture into a custom san serif font, which evokes the studio's modern, minimalist design, and whose thick, bold strokes refer to the studio's vast size. To further stress the architectural nature of the mark, the dot on the "i" was left out, as it would have added a disjointed element to the otherwise continuous forms. Next, the team experimented with secondary fonts for the company's name, ultimately choosing AG Schoolbook Rounded, both for its simplicity and for its slightly curved letterforms, which soften the severity of the mark's vertical and diagonal geometry. The logo's colors also refer to the studio's architecture: the white, black, and warm gray match Milk Studios' walls and fixtures.

What Works

The studio's logo, the word Milk overlaid with the company's name spelled out in AG Schoolbook Rounded, visually references the series of white, industrial columns that support the studio's soaring interior. In most applications, the logo appears twice: once so that Milk is readable as a word, a second time, reversed, so that it's read as a symbol, the letterforms transformed into bold, architectural forms.

FIRM

Base

Client

When the New Mexico Museum of Natural History
embarked on an expansion project, the institution
needed a logo that could be applied to fundraising
materials and museum signage. Because families
make up the majority of the museum's visitors, the
logo needed to appeal to both adults and children.

DESIGNER
Tim McGrath

FIRM
Rick Johnson & Company

Process

For designer Tim McGrath, the first step in creating what would become Toolasaurus
was finding a means to visually communicate three pieces of information: museum,
warning, and construction. He quickly chose a dinosaur to convey the first, a road
sign for the second, and different approaches for the third. Early sketches included
a dinosaur surrounded by scaffolding, another draped in a drop cloth, another com-
posed completely out of tools. But after looking at these sketches, McGrath felt they
weren't working. "I was getting too hung up on making the dinosaur look anatomi-
cally-correct. The drawings looked too technical," he says. So he started over, reduc-
ing the dinosaur to a simple, bold outline, and replacing the dinosaur's head with a
single tool, a hammer. He then refined the image in Illustrator. The result is a logo
that can be easily reproduced in any size, whether small, as in a newspaper ad, or
very large, as in the cut vinyl banners that later hung across the museum's exterior.

What Works

Nicknamed "Toolasaurus" by museum staff, the logo employs several forms of visual
shorthand to communicate the museum's expansion plans. The image of the
dinosaur, which refers to the institution's most popular exhibit, connects the logo to
the museum; while the animal's head, a hammer, suggests construction or repair.
Further, the colors yellow and black, instantly recognizable from road signs and con-
struction sites, signals warning or danger; while the actual style of the logo, namely
the dinosaur's cartoon-like depiction, tempers this warning with a touch of humor.

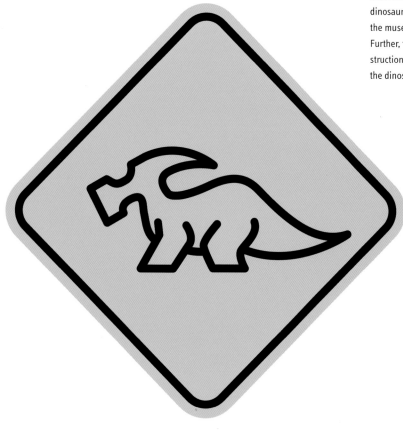

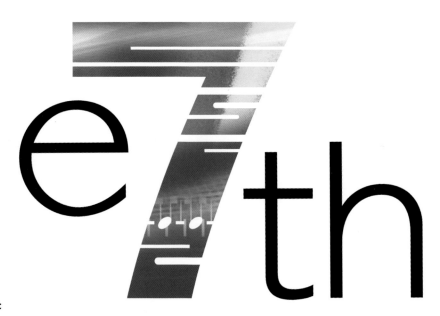

Client

e7th is an online business-to-business portal for the
fashion industry.

Designers

Martine Channon, Thomas Bossert, Carlos Sanchez

Firm

St. Aubyn

Process

When iWork Networks came to the Manhattan-based design firm St. Aubyn, the
company needed a visual identity for a business-to-business portal it was about to
launch called Shoe.net. "The company was going to start out with a site for the
footwear industry, but its ultimate ambition was to expand into the fashion industry
as a whole," explains Maria V. Nunes, a partner at St. Aubyn. "So the first thing we
did was recommend a change of name to something that would communicate fash-
ion rather than simply shoes and that would convey the notion of fashion meets
business." The result was "e7th," a name derived from the letter e, which connotes
the Internet, and 7th, which refers to the Seventh Avenue location of Manhattan's
garment industry. Next, the design team focused on logos. "We wanted the logo to
capture the cachet and energy of Seventh Avenue," says designer Martine Channon,
"and yet, because the name, e7th, is so powerful, we didn't want anything that
would detract from it." The solution was to transform the name into the mark itself,
by featuring a large 7 filled with abstract, energetic forms. "The idea is that over
time, the 7 will be filled with different textures and typography and motion so that it
becomes a personal window onto Seventh Avenue," says Channon.

What Works

The company takes its name from Seventh Avenue, the home of Manhattan's gar-
ment district. The logo visually conveys the energy of this district by featuring a 7
composed of abstract blue and white forms that prompt various associations with
urban life, including reflections in shop windows and the blur of movement that
characterizes a bustling marketplace.

The logo for a Canadian resort begins as a series of conservative type treatments and winds up a distinctive symbol.

rough drafts/final drafts

Designer Steve McGuffie begins by exploring type treatments. An early approach features the company's name enclosed in a rectangular shape and separated by a curved line to suggest a cliff overlooking the sea.

A concept for a symbol emerges: an image of a setting sun.

Next, McGuffie experiments with treatments that incorporate ocean imagery such as wooden moorings and ripple patterns.

The sun is replaced with an "O," the first letter of the company's name. Further refinements lead to an obscuring of the lower part of the O with a ripple pattern to suggest a setting sun and the choice of an Old Style typeface to convey a sense of elegance.

Client

Ocean Ridge Resort and Spa is a vacation spot located in Parksville, a rustic, seaside community on Vancouver Island in Canada.

What Works

The logo, an uppercase O set in Adobe Garamond whose lower half is obscured by a ripple pattern, suggests one of the simple pleasures that the Ocean Ridge Resort and Spa offers: the sight of a sunrise or moonrise over the Pacific Ocean.

DESIGNER

Steve McGuffie

FIRM

Realm Communications

The final Logo

McGuffie chose Adobe Garamond as a typeface due to its elegant, sophisticated feel, which suited the image the resort wanted to convey. For color, he chose blue. "A conservative choice," he admits, "but because it's the color of sky and water, there's a reason for its use." For certain applications such as faxes, an outlined version of the logo is used.

classic logo

The first Herman Miller logo, a stylized "M" meant to represent the first letter of Miller, appeared in 1946. Since then, a circle has been added to the mark, but otherwise Irving Harper's simple design has remained virtually unchanged for nearly half a century.

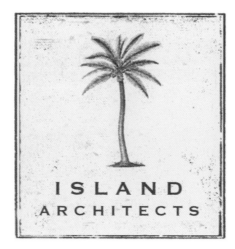

Client
Island Architects is an architectural firm that specializes in high-end residential buildings.

Art Director/Designer
David Lecours

Illustrator
Mariko Kitano

Firm
Lecours Design

Process

When Island Architects came to Lecours Design looking for a logo, the architectural firm was hoping for a mark that would reflect the location of its offices—in La Jolla, California, and the U.S. Virgin Islands—as well as appeal to an upscale, sophisticated audience. For designer David Lecours that meant creating something that had "an Old World colonial feel to it." Inspiration came from looking at nineteenth-century etchings depicting the palm trees, sand, and sea of the Virgin Islands. "We did several explorations based on these prints, but we seemed to keep coming back to the palm tree," says Lecours. "As a symbol, a palm tree can refer to an island or to coastal California so it seemed an appropriate image for this particular firm." After a palm tree was created in Illustrator, Lecours added the company's name beneath it, opting for Copperplate as a typeface, as its serif letterforms echo the typography found in Old World prints. Next, he encased the tree and logotype within a square and added texture. "We wanted the final mark to have a bit of a distressed, weathered texture so that it would feel like something from the past," he says. For color, he chose off-white, to suggest a piece of paper slightly yellowed with age, and a muted blue-green to evoke the sea and sky.

What Works

The logo, a square containing a drawing of a palm tree and the company's name set in Copperplate, borrows imagery from nineteenth-century travel prints to create a sense of Old World sophistication.

Client

Netflix is an online service that offers DVD movies
delivered free to customers' homes.

ART DIRECTOR

Jill Savini

FIRM

MarchFirst

Process

When Netflix came to the design consultancy MarchFirst, the DVD movie company
already had a logo—a yellow and black wordmark featuring the company's name in
lowercase letters—but was hoping to replace it with one that better communicated
movies in general and the positive emotions associated with movies in particular.
"We wanted people to look at the logo and experience feelings of warmth, nostal-
gia, and excitement. And yet because we are a modern service, we wanted the logo
to have a contemporary feel as well," says Leslie Kilgore, Netflix's Vice President of
Marketing. To Jill Savini, a MarchFirst creative director, that meant concentrating on
classic designs rather than edgy ones and type treatments rather than symbols. "We
wanted to avoid imagery like film reels or video screens not only because they are
over-used, but because they don't convey any sense of the romance and thrill of
watching movies," says Savini. Instead, her team focused on designs that would
somehow conjure up the 1940s, a time when a trip to the movies meant grand
theaters with red velvet curtains and wide screens. For inspiration, the team turned
to vintage movie posters and began developing marks based on their typography.
The result was a streamlined type treatment featuring the company's name set in all
capitals with drop shadows behind each letter and arranged in an arc. "The sans
serif capitals convey a sense of strength and power, and the arc communicates a
sense of grandeur," says Savini, who adds that the letterforms, being vertical, hard-
edged, and devoid of curves, reinforce this sense of grandeur. For color, red and
black were chosen to prompt associations with the red carpets, seats, and curtains
found in movie theaters of old.

What Works

The logo, which consists of the company's name set in capital letters and arranged
in an arc, prompts several associations with movies, including vintage movie posters
and the famous Hollywood sign perched in the hills above Los Angeles.

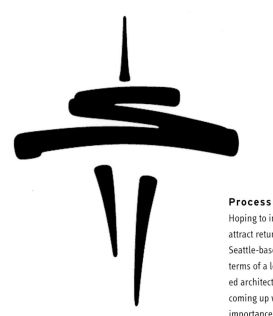

Client

Originally built for the 1962 World's Fair, the Space Needle is a popular tourist attraction located in Seattle, Washington.

Art Director

Jack Anderson

Designers

Jack Anderson, Mary Hermes, Gretchen Cook, Andrew Smith, Julie Lock, Amy Faucette, Belinda Bowling, Elmer De LaCruz, Holly Craven, Ensi Mofasser, Cliff Chung, Alan Florsheim

Firm

Hornall Anderson Design Works, Inc.

Process

Hoping to increase tourist attendance to the Space Needle while at the same time attract return visits from locals, the owners of the Space Needle commissioned Seattle-based Hornall Anderson Design Works to create a new brand for the site. In terms of a logo—just one element in a far-reaching branding campaign that included architectural signage, merchandising graphics, and business papers—this meant coming up with a design that somehow conveyed the Space Needle's historical importance while at the same time emphasizing its modern-day appeal, says HADW co-founder Jack Anderson. "The original logo the company had before coming to us was a very literal, almost photographic depiction of the Space Needle in full view. It was clear that the logo stood for the Space Needle, but it didn't have any spirit or vitality," says Anderson. To remedy this, the HADW team explored a range of different possibilities, from streamlined wordmarks to abstract symbols. One early design was simply a circle, intended to suggest the 360-degree view the Space Needle provides; while another depicted rectangular planes meant to suggest a horizon. However, these designs were soon abandoned in favor of an illustration. "For merchandising reasons, we determined that the logo needed to depict the Space Needle's architecture," Anderson explains. "But we didn't want the depiction to be literal. We wanted to it to have a gestural, energetic quality to it." To this end, the team experimented with designs that featured only the top of the Space Needle and omitted the monument's base and struts. "The top of the Space Needle is where the real personality lies," says Anderson. "On a foggy day, that's what you see: the Needle's spire and the flying saucer-like shape of its observation deck." To render the mark, the team chose to use four gestural, almost calligraphic strokes, to give the mark an energetic feel, says Anderson. The result, he adds, is a mark "whose imagery references the past but whose style celebrates the future."

What Works

Composed of brush-like strokes, the logo features a stylized illustration of the Space Needle's silhouette as well as the letter S, the first letter of the attraction's name.

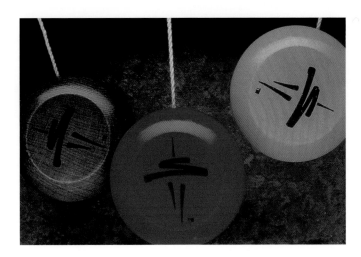

Process

After years of change and expansion, The Tate had become three galleries—London Millbank, Liverpool, and St. Ives—each with a different collection and focus. When a fourth branch, which would house the museum's collection of modern art, was to open in London, Tate management saw a need to clarify the museum's identity to better compete for patronage on a global scale. To this end, the London-based brand consultancy Wolff Olins was commissioned to create a new global Tate brand, one that would unify all four branches under one idea and one symbol.

The Wolff Olins team began by working closely with the museum to come up with a single phrase that would sum up the heart of the new Tate brand. The result was "Look again, Think again," a phrase that emphasizes the experience of viewing art, rather than the institution's collection, and that offers both an invitation and a challenge, says Paul Townsin, the project's creative director. "The idea was to make the viewing of art accessible and entertaining, but without dumbing it down or making it seem superficial," he says. Next, the team translated this concept into a visual identity, the first step being a name change. Although "The Tate" was instantly recognizable worldwide, it had also become increasingly confusing as it seemed to refer to one location not four. As a remedy, the Wolff Olins team dropped the definite article "the," renaming the institution Tate, and its four branches Tate Britain, Tate Liverpool, Tate Modern, and Tate St. Ives.

With the new names in place, the team turned to logos, hoping to come up with a design that was simple enough to function well in a range of media and sizes, yet expressive enough to convey Tate's accessible and forward-thinking approach to art. Inspiration came from two sources, says Wolff Olins designer Marina Willer: the fluidity that characterizes the viewing of art and the accessibility that characterizes a bustling public square. To visually convey fluidity, the team experimented with logos that incorporated change, designs whose basic style remained consistent but which came with many different versions. And to visually communicate accessibility, the team turned to neon signs. "Neon is an inviting, approachable medium," explains Townsin. "It says 'Our doors are open. Come get some good stuff here.'"

To create the mark, the design team experimented with a range of typefaces. "Serif faces were too classical and old world for our purposes," says Townsin, "and many of the sans serif faces, like the Helveticas, seemed too stiff. We wanted the mark to be of the new world, the new generation." With this in mind, the team created a new typeface, one whose simple strokes give it the readability of Helvetica, but whose soft, rounded edges lend it a contemporary feel. Next, a neon sign was made in the typeface, then photographed and animated. From this motion sequence, Willer grabbed a series of stills and generated a range of logos that appear to be in and out of focus. A similarly fluid palette was also developed, one that ranges from moody, subdued blues to cheery neon yellows. Regarding the end result, Townsin says: "The logo is designed so that it doesn't have a defined edge. It is meant to keep changing, to keep evolving, to keep moving as if it were alive."

What Works

While the logo's basic form—the museum's name set in a custom sans serif typeface—always remains the same, the mark's color and resolution continually changes: Sometimes it appears in neon hues and crisp focus; other times, in subdued colors and blurred. The logo's fluidity is meant to mirror the dynamic nature of an art museum experience and reflect the endless interpretations that art can invoke in viewers.

Client
Tate is a group of four British art museums whose collection ranges from historical masterpieces to contemporary art.

Firm
Wolff Olins

techy logos

Client

Media & Beyond is a retailer specializing in high-end technological products and services.

ART DIRECTOR
Bob Beck

CREATIVE DIRECTORS
Daniel Fortin, George Fok, Marc Serre

FIRM
Epoxy

Process

To distinguish itself from its rivals in the crowded category of technology retailers, Media & Beyond decided to forgo hard-sell marketing tactics and focus on high-end quality instead. To reflect this business decision, designers at the Montreal-based firm Epoxy hoped to create a logo "that didn't rely on bells and whistles, but rather was minimal and sophisticated," says designer Marc Serre. The team began with customized type treatments of the company's name, which evolved into a pared-down monogram. To connect the mark to the client's business, the designers circumscribed the M within a square with rounded corners so that it would resemble a computer key, then added an arrow, also based on a computer key. The result was an anagram of the company's name. Next, the mark was blurred to temper the potentially cold, streamlined forms with a softer, more low-tech feel. The team chose green for the logo's color, both for its connection to old-fashioned computer screens and as a way to stand out among the ubiquitous blues and reds of other technology firms.

What Works

The logo is an anagram of the client's name. The M stands for "Media"; the arrow, for "Beyond." And while the logo's streamlined forms reflect the client's products and services—cutting edge technology—the blurred treatment, which recalls the low-tech look of early computers, lends a non-threatening feel to the client's identity.

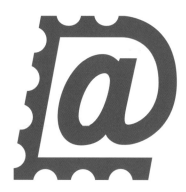

Client

AmazingMail.com allows customers to create customized postcards on the Web. The company will then print, stamp, and send the results through the mail.

ART DIRECTOR

Russ Haan

FIRM

After Hours Creative

Process

For designer Russ Haan, the biggest challenge in the AmazingMail.com project was finding a way to visually convey what the company does. "If a client has a hundred-million-dollar-a-year advertising budget, it doesn't matter whether its logo communicates anything because meaning can be built through advertising," he says. "But for businesses that don't have that kind of money, I believe a logo should communicate something right away." In the case of AmazingMail.com, Haan decided that "something" should be the online nature of the business as well as the mail-related service that the company provides. As for the style, Haan strove for a bold simplicity so that the design would work well across a range of computer platforms and browsers. His team began by exploring postal imagery, creating sketches of mailboxes, packages, and postal trucks. "But none of these conveyed the digital side of the client's business, so we moved on," says Haan. Next, he added digital components to the postal imagery, creating one design, for example, that featured a mailbox turning into a series of pixels. Out of these experiments arose the idea of combining a postage stamp with an A, the first letter of the client's name. When Haan set the A in lowercase, he noticed it suggested the @ symbol, an instantly recognizable reference to the Internet. Scanning these sketches into Illustrator, Haan refined the design, adding a jaunty tilt to the mark to give it a friendly feel. For color, he chose blue and red not only for their bold appearance, but for their connection to the palette used by the United States Postal Service.

What Works

The logo is composed of two recognizable icons: an @ symbol and a postage stamp. While the @ suggests a company that conducts business on the Web, the mark's scalloped, stamp-like outline communicates "mail."

Client

Ecast is a San Francisco-based technology company specializing in jukebox systems that allow patrons to download music and games directly from the Internet.

CREATIVE DIRECTOR
Julie Tsuchiya

ART DIRECTOR
Mark Sloneke

DESIGNER
Andrew Harding

FIRM
Extraprise/Tsuchiya Sloneker Communications

Process

In developing what would become the Ecast logo, designers at the San Francisco-based Extraprise/Tsuchiya Sloneker Communications hoped to create a mark that felt both corporate, to position the client as an established, national company, and fun and approachable, to appeal to potential customers not necessarily familiar with cutting-edge technology. As a starting point, the design team looked at vintage juke-boxes from the 1940s and 1950s as well as the client's modern-day model, a system whose sleek, curved lines reminded creative director Julie Tsuchiya of "a spaceship version of a jukebox." The team experimented with different ways to visually represent both the old and new jukeboxes in a single mark, eventually coming up with the idea of a single record: as a symbol, an old-fashioned LP evokes the non-intimidating feel of a low-tech world, explains Tsuchiya, while as a form, a record's elliptical shape echoes that of the client's high-tech product. The idea was then refined in Illustrator, where curved lines were added to the record to evoke a spinning motion, and a second oval shape was added underneath the first to represent the shadow cast when a record drops onto a turntable. The record was then given a rakish tilt to visually convey a sense of playfulness, and green was chosen for color to help the mark stand out from the blue's found in other technology companies' logos.

What Works

The logo, composed of two tilted ellipses, suggests a spinning record on a jukebox as well as a lowercase e, the first letter of the company's name.

Emily Travis Product Manager
emily@ecastinc.com

Direct 415.659.3101

Ecast. Inc.
650 Townsend Street №375
San Francisco CA 94103
Main 415.659.3260
Fax 415.659.3201
www.ecastinc.com

classic logo

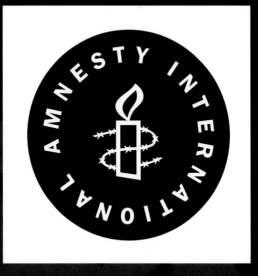

Originally designed by Diana Redhouse and redesigned in 2000 by Simon Endres of Kirshenbaum and Bond, The Amnesty International logo uses an economy of means to convey complex notions: Barbed wire communicates oppression, while a burning candle evokes hope.

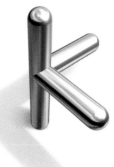

Client

KnowledgeNet is a Scottsdale, Arizona-based IT training company that offers online courses with live instructors and interactive learning.

DESIGNER
Tom Turley

3D RENDERER
Marcus Hoffman

FIRM
t-squared design

Process

When KnowledgeNet came to designer Tom Turley of t-squared design, the IT training company already had a logo—the company's name spelled out in lowercase letters with a globe in place of the o—but wanted to replace it with something that implied global technology in a more distinctive way. "We have a very sophisticated, very tech-savvy customer, so we wanted to be perceived as edgy and hip, but we also wanted to be taken seriously," says Maureen O'Leary, KnowledgeNet's marketing director. "We wanted a logo that instilled confidence, something that conveyed strength but not arrogance." To Turley, this meant avoiding over-used dotcom clichés such as swooshes, orbits, or globes. Instead, he experimented with designs ranging from the purely abstract to the literal, such as ones depicting a big dog to convey leadership to others featuring gurus to reflect the guidance the client offers its students. But Turley was unsatisfied with the results: some didn't communicate global technology, he explains, while others felt too flippant for a serious company. So he shifted courses, this time focusing on designs based on Ks, the first letter of the client's name. As he sketched dozens of Ks, experimenting with lowercase, upper case, solids, and outlines, he noticed that a signpost-like form had emerged, an image that seemed appropriate for a company providing training and direction. To make the signpost more legible, while at the same time making sure the mark remained readable as a K, Turley's team explored three-dimensional renderings. The result was a K with rounded ends, which hint at the broadband ("big pipe") technologies used by the client, and a smooth, metallic texture that reflects the client's place in the high-tech industry. Says Turley of the final mark: "Sure, it is abstract and is open to several interpretations, but I like to think about it as having 'positive ambiguity,' which creates interest and makes it memorable."

What Works

The logo, a three-dimensional lowercase k with a metallic texture, prompts several associations with knowledge, including a signpost pointing the way or a rising structure offering a sturdy foundation on which to build.

In developing a logo for a company that provides connectivity services, designers explored three different approaches: pictograms, abstract marks, and monograms.

rough drafts/final drafts

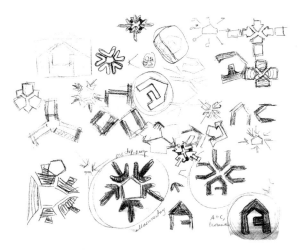

Searching for a concept, the design team begins with pencil sketches exploring images of houses to convey "home services," arrows to suggest "connectivity," and the initials A and C to represent the client's name.

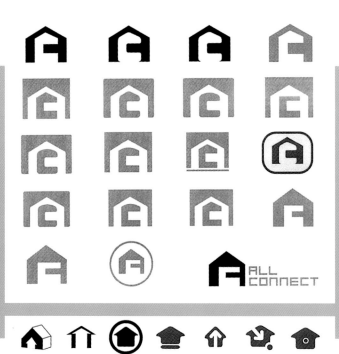

Initial concepts are fleshed out in Illustrator. Designs based on houses are eventually abandoned in favor of a more dynamic design.

A second approach, abstract designs featuring arrows, is ultimately abandoned in favor of a design with a stronger link to the company's name.

Client

AllConnect is an online company that provides a one-stop resource for comparing, selecting, and ordering home connectivity services such as Internet, cable, and cellular phone access.

What Works

Based on the idea of "connectivity," the logo features a rectangular outline whose form suggests an electrical outlet and which contains a lowercase c plugging into a lowercase a.

CREATIVE DIRECTOR

Michael Taylor

DESIGNERS

Ali Harper, Rebecca Klein

FIRM

Merge

The final logo
Its slight tilt suggests movement. The color blue conveys stability and calm.

A third approach, based on the company's initials a and c, is deemed the most successful. The design team experiments with different type weights and configurations to visually communicate "connectivity," while making sure the letters remain recognizable.

Client

Eazel is a company that develops graphical
interfaces for the operating system Linux.

ART DIRECTOR
Gordon Mortensen

DESIGNER
P.J. Nidecker

FIRM
Mortensen Design

Process

As a starting point, art director Gordon Mortensen experimented with designs based
on the word "easel," a play on the client's name and a symbol that connotes creativi-
ty. But the approach was soon abandoned. "No matter how hard we tried, the sym-
bol always wound up looking like something for an art store," says Mortensen. So he
and designer P.J. Nidecker shifted courses, focusing instead on the concept "Easy
Linux," which refers to the user-friendly interfaces the company develops. The first
step was to break up the company's name into Eaze and L; the next was to reinforce
this separation visually. This was accomplished both through form, by placing "eaze"
and "L" into separate modules, and through type, by using lowercase letters for the
first part of the company's name and an uppercase letter for the last. Further refine-
ment led to the use of Template Gothic, a typeface whose hybrid letterforms—part
clunky computer font, part clean and elegant sans serif—hint at the way computer
interfaces translate machine language into a human one. As a final touch the "a"
was replaced by an upside down "e," to create a playful bounce in the logotype,
underscoring the youthfulness and energy of the new company.

What Works

The logotype, a compact capsule containing the company's name spelled
out in Template Gothic, separates the company's name into two parts:
"Eaze" which refers to the company's goal of creating user-friendly prod-
ucts, and "L" which stands for Linux. Taken together, the two elements
allude to the phrase "Easy Linux."

The Eazel logo
underwent nearly fifty
different color studies
but only after the design
was perfected in black
and white. "If a logo
doesn't work in black
and white," explains
Gordon Mortensen, "it
doesn't work at all."

classic logo

MOTOROLA

Referred to as the "Emsignia" by the company and "the batwing" by its fans in the design community, Motorola's stylized M monogram was first introduced in 1955. Designed by the late Morton Goldsholl, the original symbol was not surrounded by a circle, but instead appeared with a variety of different design elements such as squares and ellipses. In 1965, however, the M monogram and the circle became inseparable. Since then, other than refinements to its configuration and prescribed usage, the Emsignia has remained virtually unchanged for nearly fifty years.

Client

Virtual Design Company is a California-based computer design firm.

Art Director
David Lecours

Designer
Van Duong

Firm
Lecours Design

Process

To reflect the three-dimensional, interactive structures that the client creates, designer David Lecours hoped to devise a logo that suggested both depth and movement. "From the beginning we were thinking about how the logo would work both as a static image and as a moving one," says Lecours. "We wanted a viewer to be able to enter the logo and, in a sense, interact with it in the same way that viewers can enter virtual spaces and interact with them." Early explorations, which were two-dimensional, centered around the letter V made up of overlapping, translucent planes. Hoping to create more depth, Lecours's team shifted to three-dimensions, incorporating a translucent V into a rectangular outline. "The idea was to visually communicate 3-D space," says Lecours of the final mark. "The fact that the V inside the square is translucent is meant to communicate the idea of a screen through which a viewer can visualize an actual space in the real world." For color, he chose a vibrant orange. "People seem to have a strong reaction to orange," says Lecours. "They either love it or hate it; either way it gets an instant emotional reaction."

What Works

The logo, a letter V encased within a three-dimensional rectangular outline, is based on the client's product: virtual spaces created on the computer.

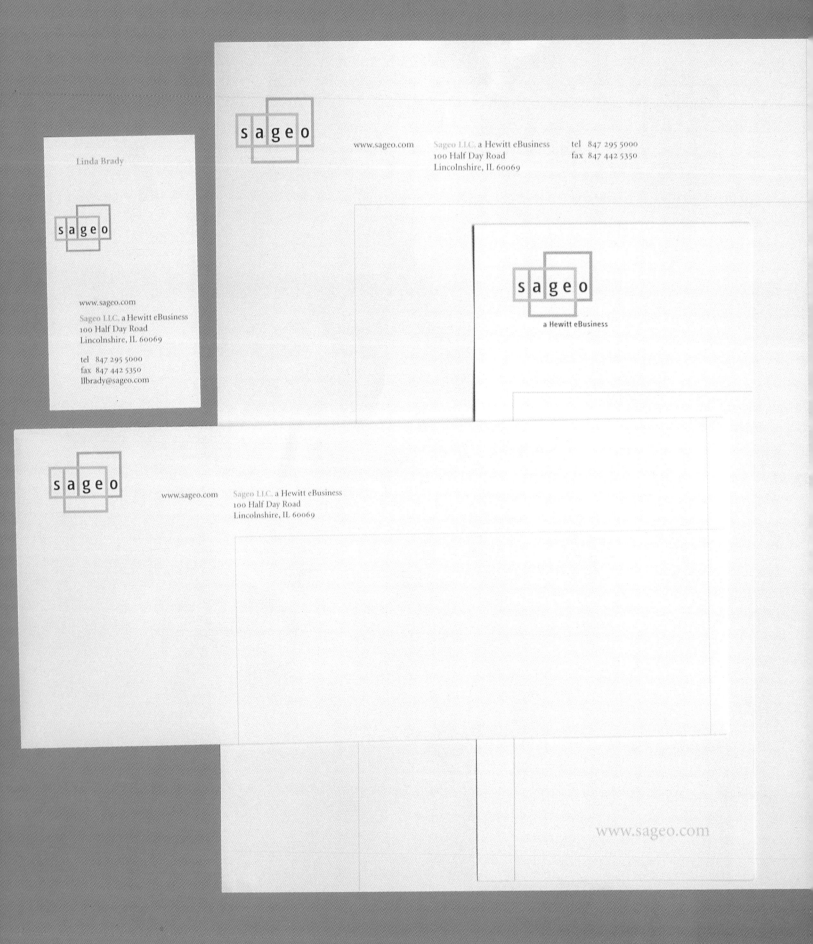

Linda Brady

sageo

www.sageo.com

Sageo LLC, a Hewitt eBusiness
100 Half Day Road
Lincolnshire, IL 60069

tel 847 295 5000
fax 847 442 5350
llbrady@sageo.com

sageo

www.sageo.com Sageo LLC, a Hewitt eBusiness tel 847 295 5000
100 Half Day Road fax 847 442 5350
Lincolnshire, IL 60069

sageo

a Hewitt eBusiness

sageo

www.sageo.com Sageo LLC, a Hewitt eBusiness
100 Half Day Road
Lincolnshire, IL 60069

www.sageo.com

a Hewitt eBusiness

Client

Sageo is an e-commerce venture that helps
employers buy and manage benefit packages
for employees and retirees.

PROJECT DIRECTOR
Paul Travis

FIRM
MetaDesign

Process

When Hewitt Associates set out to launch a new e-commerce venture specializing in
employee benefit packages, the human resources consultancy turned to MetaDesign
for help in creating a corporate identity for itself. The goal, says MetaDesign project
director Paul Travis, was to create an identity that conveyed both dependability and
approachability. "The venture was aimed at a mature audience so we felt the identi-
ty needed to suggest a sense of stability and expertise. And yet, we didn't want it to
feel too corporate or cold, so we hoped to create something that had a humanistic
feel to it as well." The first step was coming up with a name. The result, created by
the San Francisco-based firm Metaphor Name Consultants, was "Sageo," a mixture
of the word "sage," meaning a person with wisdom, and the prefix "geo," connoting
"global." Next, the design team turned to visuals, coming up with six possible direc-
tions, ranging from straight logotypes to symbols shaped like seeds to suggest
growth and infinity symbols to represent longevity. But it was a design based on
three overlapping rectangles that stood out, says Travis, explaining that the final
logo's clean, geometric forms lend it a corporate feel, while the colors—a palette of
soft blues and greens—add a humanistic quality.

What Works

The logo, which features three overlapping rectangles containing the company's
name set in the typeface Infotext, is meant to reflect the three different types of con-
tent provided by the Sageo website, namely, information on health care, wealth
management, and leading an active life.

playful logos

headstrong

earthsmartcars™

Client
Launched by the environmental group Natural Resources Defense Council (NRDC), EarthSmartCars is a campaign that aims to educate the public about the importance of environmentally friendly cars and to push for legislation that would require cars to be built with reduced emissions.

ART DIRECTOR
Bethlyn B. Krakauer

DESIGNERS
Bethlyn B. Krakauer, Lee Lipscomb

ILLUSTRATOR
Leo Espinosa

FIRM
i.e. design

+

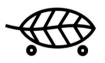

=

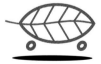

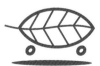

Sketches show experiments with the shape of leaf and the placement of the veins and wheels.

Process
Art director Bethlyn B. Krakauer and her team experimented with several approaches before coming up with the final design. One focused on the environment and consisted of three icons: a cloud, a sun, and a raindrop. "It was a nice solution but it just didn't tie into the car world," says Krakauer. Another approach emphasized the automotive industry and involved a series of sketches of cars in outline. These too were rejected. "We ran into the problem of does it look too much like a toy car—too much like a 1965 Chevy? We needed something more universal," says Krakauer. Her team ended up combining the two approaches—environment and cars—and came up with the idea of a leaf on wheels. Rough sketches were sent to Leo Espinosa, a comic book artist, who refined the design, first by hand, adding details such as italicized wheels to suggest motion, then in Illustrator. A drop shadow was later added to suggest three dimensions, and the typeface Vag Rounded Bold was chosen for its friendly, almost child-like feel. The result, says Krakauer, is a design that helps transform the potentially dry subject of car emissions into an accessible one.

What Works
The logo, a cartoon-like leaf atop two wheels, has a playfulness that appeals to both children and adults, and a simplicity that makes it adaptable to a broad range of media, including metal plates that the NRDC hopes will one day be applied to cars meeting reduced emissions standards.

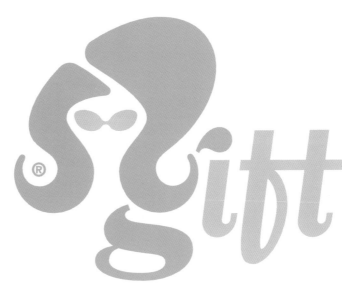

Client

Gift is a line of shirts sold by Molly Enterprises, a company specializing in clothing for teenage girls.

ART DIRECTORS
Mike Calkins, David Bates

DESIGNER
Mike Calkins

FIRM
BC Design

Process

Because fashion styles change quickly in the teen market, the Gift logo was meant to be a temporary one: used for a season then replaced with another. Thus, the Gift mark did not have to be timeless, but it did have to be stylish, both to reflect the flashy feel of the Gift clothing line and to appeal to the fickle teen market. For inspiration, designers Mike Calkins and David Bates turned to That Girl, a 1970's TV sitcom that starred actress Marlo Thomas as a spunky woman with a penchant for miniskirts and go-go boots. Using the sitcom's stylized logo as a jumping-off point, Calkins created an illustration of a woman in Freehand, paring down the design to just two elements: hair and sunglasses. "I like to think of her as Marlo Thomas's younger, naughtier sister," says Calkins of the result. He chose Matrix Script as a typeface, because, he says, "it has a feminine quality without being fussy," then manipulated the illustration so its outline would form the bowl of a lowercase g. To further tighten the link between type and illustration, he created a teardrop shape to serve as both the ear of the g and the dot of the i. For color, he chose a garish orange and blue to pump up the wordmark's playfully flamboyant feel.

What Works

The logo, which combines a script font with an illustration of a woman sporting a 1970's hairdo and sassy, cat's-eye sunglasses, uses retro imagery to simultaneously evoke glamour and poke fun at it.

NATIONAL MARITIME
MUSEUM CORNWALL

Process

Hoping to attract national and international visitors alike, the National Maritime Museum Cornwall wanted a mark that had immediate visual appeal to a wide range of cultures. Paul Cilia La Corte, who was responsible for the design, knew the mark had to refer to the museum's collection of boats, but hoped it would also convey a sense of the museum's location in Cornwall, an area of dramatic cliffs and sweeping views of the sea. One approach involved combining nautical elements into a sea captain's face; another featured a seagull made from a boat's reflection. Neither, however, produced what Cilia La Corte was looking for: a sense of the museum's friendliness combined with the poetry of the sea. Shifting courses, he sought out images of small boats from the museum's collection as well as information about Cornwall's history. "Cornwall has quite a long tradition, not only in boats, but in art as well," says Cilia La Corte, referring to the British art movement that grew out of the artist's colony of St. Ives, Cornwall, in the 1940s. In particular, he was drawn to the work of painter Ben Nicholson, whose spare, geometric abstractions evoke the wide-open spaces of the sea. Using forms similar to those found in Nicholson's work, Cilia La Corte created a design that could be read both as a sailor in a boat and as a scene depicting a cliff, the sea and the sun. The result, Cilia La Corte hopes, gives "a sense of pleasure of being by the sea and messing about in boats. It's intended to be inviting and involving."

What Works

The logo, composed of two curved shapes and a circle, encourages multiple readings. On the one hand, the curved forms suggest a sailboat; the orange circle, a sailor. On the other, the curved forms evoke the silhouette of cliffs and sea; the circle, a setting sun. Both interpretations capture the spirit of sailing celebrated by the museum.

Client
The National Maritime Museum Cornwall
is a British museum devoted to nautical history.

DESIGN DIRECTOR
Mary Lewis

DESIGNER/TYPOGRAPHER
Paul Cilia La Corte

FIRM
Lewis Moberly

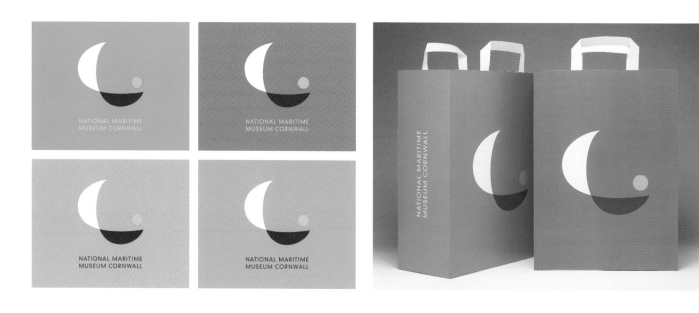

PLUTO'S

FRESH FOOD FOR A HUNGRY UNIVERSE

Client

Pluto's is a San Francisco-based restaurant that serves healthy fast food.

DESIGNER
Mitchell Mauk

FIRM
Mauk Design

Process

The only specific request the client gave designer Mitchell Mauk was to create something "fun," to which Mauk added "but not trendy" so that the logo would not become outdated quickly. With these parameters, Mauk decided on an approach that would mix and match past design styles in order to create a fresh-looking hybrid. Drawn to the biomorphic forms popular in the late 1950s, both for their playful look—"some of the shapes back then got really, really wild," he says—and for their association with food establishments, he used Illustrator to create asymmetrical letterforms, drawn as a single line with a fill. Next, he turned to the 1970s for a palette that would lend a more contemporary feel to the 50s shapes, ultimately choosing a vibrant mix of avocados, oranges, purples, and mustards. Of the result, Mauk says, "We're really conscious of not participating in fads. By coming up with a design that incorporates elements of 50s and 70s design—periods that have already gone out of date at least twice before—I think we've created a design that will endure."

What Works

Just as Pluto's combines two types of food—fast and healthy—to create a hybrid cuisine, so the logo blends elements from two different eras, the 1950s and the 1970s, to convey a contemporary message. While the 1950s-inspired letterforms evoke the friendly feel of roadside diners, the brash palette, culled from 1970s design, adds a playful flash. The resulting logo conveys a sense of friendliness tempered with a dash of irony.

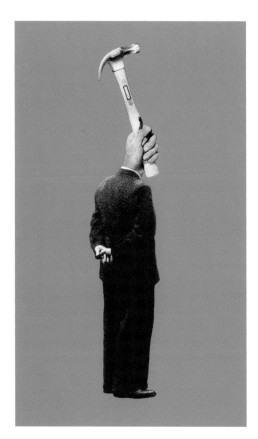

Process

Designer and collage artist John Borruso hoped to create a logo that would reflect the creative energy of the client's services, yet would soften the name, which could be mistaken as aggressive rather than irreverent. He began by creating collages based on old-fashioned television sets. One consisted of a TV set with "SmashTV" splashed across its screen; another depicted a TV surrounded by an eye-popping starburst pattern reminiscent of the hard-sell ads of electronic stores. Neither solution satisfied Borruso, who found them not distinctive enough. So he shifted his focus away from the word "TV" to the word "smash," and began experimenting with ways to visually communicate the act of creative rebellion. In his collection of old tool manuals and vintage magazines, Borruso found a photo of a hand holding a hammer, which evoked the word "smash," and another of a man clad in suit, which suggested a business executive. Using Photoshop and Illustrator to combine them, Borruso found the result to be a bold yet playful illustration of rebellion. "The potential aggression of the upraised hammer is tempered by the figure," says Borruso. "He is prim. His hands are folded behind his back. So the result is humorous rather than aggressive."

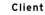

What Works

Nicknamed "Hammerhead," the logo depicts a prim, suit-clad man, whose head is a raised hammer. The mark uses wry humor to convey a message of creative rebellion.

Client

SmashTV is a company that creates Web cast programming for children.

DESIGNER AND ILLUSTRATOR

John Borruso

FIRM

John Borruso Design & Collage

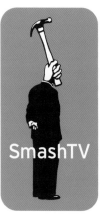

For black-and-white applications, an outlined version is used.

Client

Action Figure is an Austin-based design firm specializing in print and motion graphics.

DESIGNER
Matt Hovis

FIRM
Action Figure

Process

Like many design firms, Action Figure had created logos for numerous clients, but had put off designing one for its own business. "We couldn't figure out how we wanted to market ourselves," says Kevin Whitely, a principal of the firm. "We tried different things, got them printed, then threw them away." After months of indecision, he and co-partner Matt Hovis decided "to go dorky," as Whitely puts it. "We thought, 'Look, we're just a couple of dudes. That's all we are. Let's go for something that says that.'" So he, Hovis, and the newly hired Christa Mayre went outside and snapped some Polaroids of each other against a wall. "With Matt and I, we just fuddy-duddied out into the alley and took the pictures," says Whitely, "but with Christa, we got a little artsy. We had her make an extravagant bun." The Polaroids were then scanned into a computer, turned into silhouettes in Photoshop, and converted to vectors in Illustrator. A thick, outlined circle was added to contain the three figures, and a black-and-white palette was chosen to give the mark a 1960's feel, similar to that of the TV show "Mod Squad."

What Works

The logo features a circle containing silhouettes of two men and a woman standing with feet firmly planted on the ground and arms dangling at their sides. A humorous take on the name "Action Figure"—there's not much action, after all, in these figures—the logo reflects the playful approach the firm brings to its work.

headstrong

Client

Headstrong is an international business consultancy specializing in technology solutions ranging from IT systems to Internet and e-commerce sites.

Art Directors/Designers

Steve Watson, Lesley Feldman

Firm

The Leonhardt Group

For the company's website, the logo's three figures are used as navigational tools.

Process

When Jason Martin + Company approached the Seattle-based firm The Leonhardt Group, the business consultancy was hoping for a new name and visual identity that would better reflect its expertise in new technologies. "In the 1980s, the company was perceived as a bunch of hotshot systems, engineering, and technology guys, but over the years that perception had changed," explains TLG design director Steve Watson. "The company was now viewed as sort of old school and not very exciting." To remedy this, the TLG team began by working with the company to re-position it as a group of consultants with strong opinions, rather than one that simply told clients what they wanted to hear. Next, the team explored names that would convey this new positioning, eventually coming up with "Headstrong," a name that connotes strong brains, intelligence, and a meeting of minds. However, the name did come with risks, says Watson. "Headstrong can also connote bull-headedness and inflexibility, and obviously those are not messages the company wanted to communicate," he says. So when his team set out to design a logo, an important consideration was finding a way to temper the name's negative connotations and emphasize its boldness instead. After creating about 150 sketches of potential directions—from type treatments to abstract symbols to dozens of illustrations of heads—a concept emerged: a design that would combine the company's engineering side with its human side. To visually represent technology, Watson's team experimented with monitor shapes; to convey humans, various renderings of figures were explored. One promising design featured a stylized man whose head was a monitor, says Watson, but it was abandoned "because it looked too much like the Restroom guy." Instead, the team shifted to more realistic renderings, eventually deciding to photograph a variety of people—both professional models and TLG employees—in poses ranging from thoughtful to defiant. After culling through the results, the team selected three, modified them in Photoshop, and replaced their heads with four monitor-shaped forms. Next, a logotype was added which was based on Clicker, a face whose letterforms echo the monitor shapes of the symbol. As a final step, Watson's team experimented with color, but ultimately decided to stick with black and white "to give the figures a kind of chic, Armani-esque type feel," says Watson.

What Works

The logo, which consists of an all lowercase logotype and three human figures with monitor-like shapes in place of heads, suggests both the services the company offers and the way those services are provided: The monitor-heads and mechanical-looking logotype refer to the company's technological expertise, while the figures—two men and a woman—reflect the company's focus on individual ideas and opinions.

classic logo

The flexibility of geometric shapes is exemplified by the different yet stylistically consistent versions of the logo for The Museum of Contemporary Art (MOCA). Designed in 1984 by Ivan Chermayeff, the original logo features a blue square, a green circle, a red triangle, and a C set in Baskerville to spell the museum's monogram MOCA. When the museum later closed for construction and opened a temporary branch, Chermayeff created a second version of the logo, adding a hand-drawn carat and the letter t for "temporary." Later, when the temporary branch became a permanent facility and changed its named to the "The Geffen Contemporary," Chermayeff designed a third version, this time reorienting the square, circle and square vertically and adding an abstract purple G, created by cutting the upper-right-hand quarter out of a circle.

SUNDOG

Client

Sundog Interactive is an intranet and interactive software development company based in Fargo, North Dakota.

CREATIVE DIRECTOR
Dana Lytle

DESIGNER
Jamie Karlin

ILLUSTRATOR
Lin Wilson

FIRM
Planet Design Company

Process

Fearing it was getting pigeonholed as a company that catered solely to conservative corporate clients, Sundog Interactive hoped to adopt a new identity that would suggest the innovative work it was capable of. To the team at Planet Design, that meant coming up with a design that was simple in form, so that it would work well across a range of Web browsers and screen resolutions, but one that also had a playful feel so that it would convey Sundog's forward-thinking attitude. Using the client's name as a jumping off point, the team experimented with different designs depicting dogs and suns, then hit upon the idea of combining the two into one symbol: a dog collar whose radiating spikes suggested a sun. The design was then streamlined in Illustrator where all but the necessary highlights were eliminated so that the symbol would be graphically bold yet remain recognizable as a dog collar. For color, a golden hue was chosen to suggest both a metallic dog collar and a warm sun. In letterhead, the mark appears against a series of blue horizontal lines that can be read either as a sky or as a flickering computer screen.

What Works

The company takes its name from "sun dog," a term used to describe the luminous spots that appear in the sky in sub-zero weather. The logo, however, highlights the term's better-known connotations: a dog collar refers to America's favorite pet, the collar's spikes suggest a radiating sun.

Client

Beenz.com Inc. is a company that offers online merchants a universal, global currency that rewards purchases made on the Web. Headquartered in Manhattan, the company has branches in North America, Europe, and Asia.

ART DIRECTOR
Nicolas De Santis

FIRM
Twelve Stars Communications

Process

In developing what would become the Beenz logo, designers at the London-based firm Twelve Stars Communications worked within several parameters. The mark needed to communicate the idea of money to reflect the client's product. It needed to have a fun, friendly feel to appeal to a young audience. And it had to be understandable to viewers across the globe. As a starting point, the design team explored designs based on a single B, the first letter of the company's name, and eventually came up with a lowercase b with two horizontal strokes across its ascender. As a symbol representing a new form of currency, the mark was deemed successful and was later used as an element in the company's identity system. But as a company logo, the team felt the mark wasn't distinctive enough. "There are too many Bs out there," explains designer Nicolas De Santis, who led the project. "We wanted something that was bolder and friendlier." So the team shifted its attention to the company's name, using Photoshop to create a three-dimensional illustration of a bean. After experimenting with various shapes of beans, the team ultimately chose a kidney-shaped one, a form, explains De Santis, that suggests a smile. The team then added the company's name to the bean, using a custom typeface whose bold, friendly feel is originally based on Frutiger. Next, the team explored color. "Beenz is global so we wanted to find a color scheme that was striking, worked well around the world and would stand out when viewed on a computer screen," says De Santis. The solution was a vibrant red and white, a combination, says De Santis, whose commercial success is proven by none other than Coca-Cola.

What Works

The logo, a three-dimensional representation of a bean with the company's name spelled out across it in a sans serif face, evokes several associations with money. The bright red bean recalls the play money of children's games, while the lowercase b, which features two horizontal strokes across its ascender, calls to mind monetary symbols such as the dollar or yen sign.

Because the pun contained in the company's name does not translate into Chinese, a separate logo was created for use in China. Featuring Chinese characters, it reads "red bean," an Asian symbol for good luck.

Client

Candi Shoppe is a cosmetics company specializing in make-up for teens and college-aged women.

Designer
Paul Howalt

Firm
Howalt Design

Process

To reflect its trendy, inexpensive cosmetics, the client hoped for a logo that felt fun and energetic. And because the logo would be applied to everything from packaging to promotionals to stationery, its design had to be both eye-catching so it would stand out among competitors in a store environment, and simple so it would trans- late into sedate applications such as company letterhead. With these parameters in mind, designer Paul Howalt began experimenting with approaches based on a piece of candy, a choice that not only reflected the company's name but offered a simple graphical form with which to work. Preliminary sketches evolved into a heart-shaped design, one that was inspired, says Howalt, "by all the heart stickers I saw spilling out of the client's briefcase." He streamlined the design in Illustrator, eliminating all but the necessary highlights so that the symbol would be graphically bold yet remain recognizable as a piece of candy. For the logotype, he opted for Chunder, and added subtle modifications such as a curlicue to the C. Lastly, to further pump up the tongue-in-cheek girlishness of the design, he chose a palette of red, white, and hot pink, a combination that calls to mind Valentines, roses, and little girl dresses.

What Works

The logo, which features a heart-shaped piece of candy above a script typeface, uses hyper-feminine cliches—candy, hearts, and curlicues—both to evoke a sense of girl- ish fun and to poke fun at it.

Client

Elixir is a Manhattan-based cafe specializing in natural juices and healthy snacks.

Designer

Douglas Riccardi

Firm

Memo Productions

Process

In developing the Elixir logo, designer Douglas Riccardi worked within several design parameters, the foremost being to create an identity that would set the client apart from its many competitors. "Most juice stores have an earthy, hippie-ish feel to them, but Elixir wanted to do something different," he explains. "It decided to position itself as a modern apothecary and to stress the medicinal qualities of its products." For Riccardi, this meant coming up with a logo design that had a clinical feel to it, yet one that also had a dash of humor to prevent it from feeling cold or sterile. He began by making sketches of juice glasses, then scanned them into Illustrator where he pared down the design so that all that remained was a cylindrical block of color encased in a bold outline. To counteract the starkness of the image, he selected Clarindon Condensed for the logotype, a typeface whose slightly exaggerated serifs call to mind the energetic, playful lettering found in comic books. For color, he chose a vibrant palette of blue, green, and red, their hues based on different blends of juice sold in the client's store.

What Works

The logo, which comes in three different colors, features a glass of juice with the company's name spelled out across it in lowercase Clarindon Condensed. Reminiscent of the clean, simple lines of a laboratory beaker, the mark's design hints at the medicinal qualities of the client's products.

cafe spice

Client

Cafe Spice is an Indian restaurant
located in Manhattan.

DESIGNERS

Douglas Riccardi, Kate Johnson

FIRM

Memo Productions

Process

In developing what would become the Cafe Spice logo, designer Douglas Riccardi
hoped to create a mark that combined an Indian sensibility with an American one.
"We felt the mark needed to have an ethnic feel to it in order to visually convey the
type of food the restaurant serves, but we also wanted it to feel young and hip to
appeal to the college-aged population that lives nearby," says Riccardi. He discovered
a solution while thumbing through an Indian penmanship book that he had found on
a visit to New York City's Little India. "I started drawing some of the Indian characters
and noticed similarities between them and English letters," says Riccardi. "For exam-
ple, there's an Indian character that looks like an English C, and an accent mark that
looks like the dot in the letter I. So I decided to mix the two styles of writing togeth-
er." Working with a typographer, Riccardi constructed a logotype whose letterforms
incorporate both the teardrop shapes found in traditional Indian calligraphy as well
as the thick, bold strokes characteristic of modern typefaces. The result, says Riccardi,
is a mark "that alludes to Indian culture in a playful, modern way."

What Works

Mixing English script with Indian calligraphy, the logo consists of the client's name
spelled out in letterforms that hang from a horizontal bar above them. With its
hybrid look, the mark echoes the style of the restaurant it represents: a place where
Indian food is served in an American-style setting.

cafe spice

INDIAN BISTRO

cafe spice

INDIAN BISTRO

cafe spice

INDIAN BISTRO

cafe spice

INDIAN BISTRO

In color applications, the logo appears reversed-out from a palette inspired by Indian spices such as cinnamon and turmeric.

LA BICYCLETTE
NYC

Client

La Bicyclette is a French cafe
and bakery located in Manhattan.

Designer

Felix Sockwell

Firm

Felix Sockwell Creative

Process

In developing a logo for a new French cafe, designer Felix Sockwell began with a series of pencil sketches of different types of bicycles in a variety of drawing styles. Of these, he deemed the designs composed out of the bare minimum of lines the most successful, feeling they best reflected the simple charm of the neighborhood cafe. As he further reworked the design, a concept emerged: by replacing parts of the bicycle's outline with a knife, fork, and a spoon, the mark instantly conveyed the fact that La Bicylclette was a food establishment. He then refined the drawing in Illustrator and added the client's name set in Akzidenz Grotesk Bold in a horizontal line beneath the symbol to suggest a street. And though he experimented with color—blue and red to suggest the French flag, and red and yellow to convey a sense of warmth—he ultimately opted for the simplicity of black and white.

What Works

While the mark's imagery, a bicycle composed of two plates and a knife, fork, and spoon, conveys the fact that La Bicyclette is a food establishment, the logo's simple, playful style projects a company identity of friendliness and warmth.

Client

PocketCard is an Illinois-based company that offers prepaid expense cards via the Web.

CREATIVE DIRECTOR
Carlos Segura

DESIGNER
Tnop Wangsillapakun

FIRM
Segura Inc.

Process

Since the client conducts its business on the Web, any logo it adopted would need to translate well on a range of different computers and browsers. To designer Carlos Segura, this meant avoiding such details as thin lines, delicate serifs, and subtle color combinations as they might become distorted or disappear altogether when viewed on the Web. "With Web efforts, the design needs to be very clean and stripped down," he says. So he and his team explored different designs based on illustrations of a credit card—a simple rectangular form that works well on the Web—and on monograms featuring the letter P. These two approaches eventually merged into one, resulting in a letter P formed from a graphical representation of a folded credit card. The mark's bold central stripe reads both as a credit card's scan line and as the letter P's counter. As a typeface, the team chose the straightforward Helvetica Bold and selected green as the color to suggest money.

What Works

The logo, a letter P created out of a folded credit card, visually conveys two messages about the client. The mark's imagery illustrates the company's product—credit cards—while its simple, bold style projects a company image of strength and dependability.

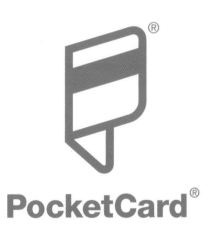

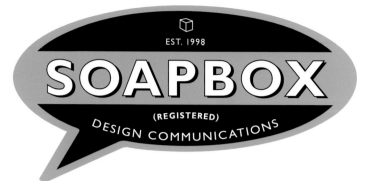

Client
Soapbox Design Communications is a Toronto-based graphic design firm.

Designers
Gary Beelik, Jim Ryce, Victoria Primicas

Firm
Soapbox Design Communications

Process
The first step in creating the Soapbox identity was finding a way to visually convey the Old World feel of a soapbox. For inspiration, designer Gary Beelik and his colleagues turned to packaging design from the 1930s and 1940s, focusing in particular on soapbox labels. From this research emerged two ideas: creating a logo that was a label or a sticker, and secondly, incorporating some of the graphic elements common in early-twentieth-century packaging design, such as ovals, eye-catching color, and all-capital letters, into the final mark. Next, the team explored different ways to update the vintage designs they had been looking at. "We are a pretty laid back firm, so we wanted to create a logo with a bit of a humorous twist," says Beelik. That twist turned out to be a speech bubble, a symbol that connotes both speech in general and the populist speech of comic books in particular. As a typeface the team chose Gill Sans, a font that was introduced in the 1930s but whose clean strokes lend it a modern feel today. For colors, the team again turned to vintage soapbox labels. "But we wanted to update them slightly," says Beelik. "We made the oranges a little bit brighter and the blues a bit more current." The result is a logo that is playful and modern, but which also carries a sense of history.

What Works
The company's name alludes to the way wooden crates were once dragged into town squares and used as improvised platforms for spontaneous speech. Visually, the logo represents this type of communication: The comic book-style bubble conveys a sense of informal speech, while the attention-getting colors and all capital letters suggest the passion and urgency with which the speech is delivered. And just as Old World soapboxes were easily adaptable to a range of environments, so too is the logo: it varies in size, shape, and color depending on the application.

The logo comes in twelve variations and features six different sayings, including "Choose your platform," which is used for promotionals, and "Try to remain calm," which is applied to invoices.

CapitalThinking

Client

Capital Thinking is a business-to-business
marketplace for commercial real estate financing.

DESIGNERS
Thomas Bossert, Craig Stout, Carlos Sanchez

FIRM
St. Aubyn

Process

When the founders of the first business-to-business marketplace for commercial
real estate financing came to the design firm St. Aubyn, they were hoping to create a
brand that conveyed both a commitment to top-tier service and an unconventional
way of doing business. "Commercial real estate financing has never been an easy
business category," says Maria V. Nunes, a partner at the Manhattan-based St.
Aubyn. "There are usually a lot of under-the-table dealings that go on, making it dif-
ficult for people to know if they're getting the best deal. So the idea the client had
was to use the Internet to offer people more complete, trustworthy information." Or,
as Nunes' team concluded: "They were trying to be a bit like Saturn-meets-Goldman
Sachs—that is, providing a direct, honest approach and white-glove service." To
convey this message, St. Aubyn first came up with a name for the new business:
"Capital Thinking," a name that plays off the two meanings of the word "capital,"
namely, money and, in Britain, "the best." Next, the team turned its attention to a
logo, searching for imagery that would somehow suggest both tradition and the
new. The result was a bowler hat, a symbol, says designer Thomas Bossert, that
"represents not only the financial world, but also the place where thinking and ideas
happen: under the hat." After creating a basic bowler hat shape in Illustrator—the
paintings of businessmen by Rene Magritte served as inspiration—Bossert used
texture and color to add a modern look and feel to the mark. "We made the hat very
smooth and chose a blue/green color to make it look unusual and new," he says. The
company's name was then added in a modified version of the typeface Thesis.

What Works

The logo consists of a bowler hat and the company's name set in a customized ver-
sion of the typeface Thesis. The bowler hat, a symbol associated with the British in
general, and British businessmen in particular, communicates a sense of prestige
and trustworthiness, while the hat's rendering—its smooth texture and unusual
color—conveys a dash of irreverence.

Client

Mobile Money is a banking program that delivers financial services to a client's home or workplace.

CREATIVE DIRECTOR
Chuck Johnson

DESIGNER
Chuck Johnson

FIRM
Brainstorm, Inc.

Process

In developing a logo for a new mobile banking program, designer Chuck Johnson of the Dallas-based firm Brainstorm used the program's tagline, "Not your ordinary bank," as a jumping off point. "We wanted to create something that was friendly and had a small-town feeling to it," he explains. In addition, the logo needed to be simple enough to work well in both very small sizes, since it would be used in letterhead, and in very large sizes, as it would be applied to the sides of trucks. With these parameters in mind, Johnson began doodling, experimenting with different symbols for banks, money, and vehicles. Out of these sketches emerged the concept of "banking on wheels," which evolved into a dollar bill atop wheels. Transferring these sketches to Illustrator, he refined the design, creating a bold rectangular outline with a silhouetted head at its center to suggest money, whose upper-right-hand corner is folded downward to suggest a windshield of a van. For color, he opted for green, the color of money. As a final touch, he added a jaunty tilt to the wheels and three horizontal motion lines to convey a sense of speed.

What Works

The logo's form, a dollar bill atop two wheels, visually conveys the idea of mobile financial services, while the logo's style, a playful cartoon rendering, suggests a business that emphasizes friendly customer service.

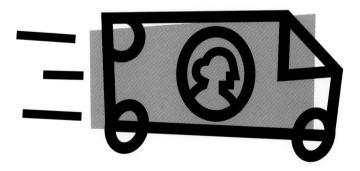

marketsnatchers™

PRODUCTS TO PROMOTE YOUR BUSINESS

Client

Market Snatchers is a provider of logo imprinted products for use in corporate promotions.

DESIGNER

Kevin Hall

FIRM

Kevin Hall Design

Process

When Market Snatchers came to Kevin Hall Design in search of a logo, the company was hoping for a mark that would appeal to small and mid-size businesses and have a friendly, rather than corporate, feel to it. To designer Kevin Hall these general criteria called to mind the phrase "a design with a human touch," and led to the idea of incorporating an image of a hand into the mark. Sketches led to further refinements, resulting in a hand snatching away the first letter of the client's name. To execute it, Hall worked with an illustrator who experimented with different iterations of hands. Some early approaches, such as a hand rendered in a smooth outline, felt too sterile, says Hall, and were later refined by adding cross hatching and shading for a more tactile appearance. For the logotype, Hall opted for the smooth, modern letterforms of Helvetica to provide a contrast to the hand-drawn hand. For color, he chose black and red to lend a bold, aggressive feel to the mark.

What Works

The company's name refers to the act of one business stealing market share away from another. Visually, the logo furthers this notion—and playfully so—by featuring a drawing of a hand plucking away the first letter of the company's name.

Client

Think3 is a company that creates inexpensive, easy-to-learn three-dimensional design software.

Designer

Keith Anderson

Firm

Eleven Inc.

think3

2880 Lakeside Drive, Suite 250 Santa Clara, CA 95054
t408.987.2200 f408.727.0237 www.think3.com

Process

The idea for the logo evolved out of early sketches designer Keith Anderson made of people thinking. Aiming for both simplicity and boldness, Anderson eliminated the people, distilling the design down to a single thought bubble. After scanning his final sketch into the computer and cleaning it up in Illustrator, Anderson experimented with fonts, both serif and sans serif. Some, like Baskerville, Anderson deemed too sophisticated for the feisty, upstart company; while others, like Trade Gothic, felt too technical and cold. Anderson ultimately chose Clarendon, which, with its exaggerated, bulbous serifs, lends a dash of humor to the numeral three. And though Anderson first used red as the logo's primary color, he ultimately decided it wasn't distinctive enough, and opted instead for an intentionally garish orange. "Orange invades you," Anderson says. "You can't turn away from it. By using it in a logo, a company conveys attitude, one that says: Lots of people may not like orange, but, hey, we don't care."

What Works

Rather than illustrating the company's product, the logo focuses on what customers do with it, namely, conceptualize and create three-dimensional objects. With its comic book-style thought bubble and a numeral three seemingly plucked from a grammar school primer, the logo alludes to the product's accessibility and helps create a company identity of playful rebellion and humor.

Before reaching its final form, the Handspring logo underwent over one
hundred different iterations. Some changes were major, such as a shift
away from a monogram to a stylized figure; others were mere details,
such as deciding how big the dot above the letter "i" should be.

rough drafts/final drafts

The Handspring logo
begins with rudimentary
pencil sketches. Here,
designer P.J. Nidecker
repeatedly draws an H,
the first letter of the
client's name. A
conceptual theme
emerges: the H becomes
a spring, which refers to
the company's use of
"springboards," modules
that expand PDA's
capabilities, and to the
company's desired image,
one of energy and verve.

Laser proofs reveal
different interpretations
of the spring concept,
all based on the letter
H. In the first, the H
performs a back flip,
while in the second,
it transforms into a
tightly wound coil.

Client

Handspring is a company that develops handheld personal digital assistants.

What Works

The Handspring logo, a stylized stick figure cart wheeling above a logotype, visually conveys the attitude of youth and vitality.

ART DIRECTOR
Gordon Mortensen

DESIGNER
P.J. Nidecker

FIRM
Mortensen Design

handspring

The third approach refers to the spring-like action of a bouncing ball, while the fourth depicts an H composed of cross-sections of springs.

Only the fifth, a stylized character caught mid-cartwheel, moves away from a literal rendering of an H. It is ultimately chosen as the approach to pursue. To stress the mark's humanlike appearance, the figure is removed from the box that once surrounded it.

The final Logo

The chosen mark, which has since been nicknamed "Flip." The colors green, blue and yellow convey a sense of youth and vibrancy.

Process

When 800.com came to Sandstrom Design, the online electronics retailer was look-
ing to replace its logo with one that better communicated the kinds of products it
sold. "One of the problems with the company's name is that people associate it with
telephones and the telephone industry rather than electronics," explains Sandstrom
designer Dan Richards. To remedy this, the Sandstrom team began experimenting
with logotypes that incorporated imagery such as sound waves, circuitry, and electri-
cal sparks. One exploration, an 800 whose 8 contained an image of a double electri-
cal socket, sparked Richards interest. Using Illustrator, he broke the 8 apart so that it
became a single socket, then flipped the bottom half-moon shape 180 degrees. This
latter step not only made the mark read as a smiling face, says Richards, "it also
made the logo more own-able: it wasn't just a socket that had been lifted and
dropped into a logo." Next, Richards turned to color: "We wanted a color that was
really bright so that the logo would have a friendly feel, yet light enough so that the
face didn't go too dark." Yellow, he says, was not seriously considered as it would
have transformed the mark into a direct quotation of a smiley face. Red was too dark
and blue "looked kind of sad." Richards chose a bright lime green, a color, he says,
"that pushes the envelope a bit and translates well in a Web environment." Of the
result, Richards says: "The logo works very hard for the company. It conveys both
electronics and customer satisfaction all in the same mark."

What Works

The logo, an electrical socket modified to resemble a smiling face, suggests the com-
pany's product—electronics—and its emphasis on friendly service.

Client

800.com is an online retailer
of electronic goods based in Portland, Oregon.

Designer

Dan Richards

Firm

Sandstrom Design

Client

The Mattress Factory is a contemporary art museum that commissions, exhibits, and collects site-specific installations.

CREATIVE DIRECTOR
Robert Handley

FIRM
Droz & Associates

Process

Hoping to increase the number of visitors to its art exhibitions, the Pittsburgh-based Mattress Factory sought the help of Droz & Associates for a new identity that would appeal both to art aficionados and to a wider, more general audience. "The Mattress Factory is one of the few museums of its kind anywhere," says Dan Droz, president of Droz & Associates. "It brings in artists from all over the world to come and build something specifically for its galleries. Rather than displaying artifacts, the museum is experience-oriented, so we wanted the identity to reflect that." In addition, the logo needed to be flexible enough so that it would function in a range of sizes and applications, from letterhead to the Web to T-shirts to three-dimensional signage. With these parameters in mind, the design team created a mark that depicts the museum's initials set in a modified version of Franklin Gothic Heavy—chosen because its streamlined letterforms allow for easy reproduction whether in print or on the Web—and whose form consists of two abutting squares, shapes that suggest building blocks that can be arranged and rearranged to form new configurations, much like the art housed in the museum. For color, red and black were chosen to convey the boldness and energy of the museum.

What Works

Just as the museum's art is characterized by its flexible, interactive qualities, so the museum's logo encourages viewer participation. Based on the museum's initials, the mark consists of an M, an upside down F, and a second F formed by the negative space between the two solid letters.

Client

Y-Not Design is a Cincinnati-based design firm specializing in corporate identities.

DESIGNER

Tony Reynaldo

FIRM

Y-Not Design

Process

Though designer Tony Reynaldo had created scores of logos for other companies, he had spent two years struggling to come up with one for his own. "The problem with doing your own logo is that you're super critical of every little thing," he says. Inspiration hit while Reynaldo was on a road trip—"I had plenty of time to think," he explains. He realized that his first name spelled backwards read as Y-not, or "Why not," a phrase that he felt summed up his down-to-earth approach to design and which would therefore make an appropriate name for his firm. To create a mark out of the name, Reynaldo first experimented with rebuses depicting a capital Y and an image of a knot. But when he showed the results to friends, he says, they couldn't decipher it. To remedy this, he added a logotype that spelled out Y-KNOT, but the resulting design was too cluttered, he says. Shifting courses, he abandoned the rebus and returned to his original idea of spelling his name backwards. For a typeface, he chose Futura for its straightforward, modern feel, then encased the letters in a vertical rectangle so that the Y would pop out. To further separate the Y from the NOT, he placed each in a different colored square, then added the word "design" at the base. For color, he chose a vibrant blue and green to convey a sense of playfulness.

What Works

The firm takes its name from the founder's first name, Tony spelled backwards. Visually, the logo reinforces this playful attitude towards design through the use of unadorned typography and bold, eye-popping color.

![webmiles.com logo]

Client

WebMiles is an online service that provides frequent flier miles in exchange for purchases made over the Web.

DESIGNER
Noreen Doherty

DESIGN DIRECTOR
Rick Atwood

FIRM
GMO/Hill, Holliday

Process

When WebMiles came to the ad agency GMO/Hill, Holliday, the company already had a logo—a lozenge shape containing the company's name—but was hoping to replace it with something more distinctive. To the design team at GMO that meant coming up with a design that somehow conveyed airline flight in a friendly, energetic way, says designer Noreen Doherty: "The customers who use WebMiles use them for vacations, not for business travel, so we didn't want the mark to end up looking cold and corporate. We wanted it to be fun and dynamic." The team began by creating a list of five words that could describe the WebMiles brand—Energy, Travel, Personality, Change, and Pro-Active—then developed a round of logos to illustrate each one. One early approach, says Doherty, incorporated illustrations of planes; another featured the WebMiles name in clouds. Both approaches were abandoned however. "They were much too literal and didn't differentiate the company from other travel companies," says Doherty. So Doherty began experimenting with wings instead, sketching designs ranging from mechanical-looking airplane wings to more organic ones based on birds and butterflies. After refining the wing shape in Illustrator, she created two more in smaller sizes, then arranged them in a fan-like configuration to convey a sense of movement. For the logotype, she chose Cosmos as a base, then modified it by adding serifs to convey a sense of forward motion. Next, she experimented with color. "Blue was the obvious choice because it connoted the sky, but in the travel industry, everything is blue so we wanted to find something more distinctive," says Doherty. To this end, the team chose a palette of oranges to suggest sunrises, sunsets, and the warm feelings associated with vacation. Of the final result, Doherty says: "We feel it reflects the excitement of travel while at the same time setting the company apart in a field of blue."

What Works

The logo, which features three wing-shaped forms arranged in a fan-like configuration, suggests movement, flight and the use of orange adds a unique and positive feel.

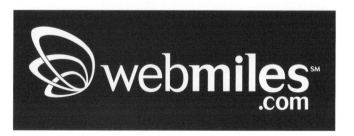

classic logo

Not only is the famous Apple logo an effective pictograph—the apple being a symbol of knowledge in general; the bite, an allusion to forbidden knowledge in particular—its playful style has had much influence on logo design. Designed by Rob Janoff of Regis McKenna in 1977, the Apple logo distinguished itself from earlier high-tech logos by incorporating humor into its design: The rainbow colors were intended to recall the post-hippie culture in which the company took root; its stripes, a playful reference to IBM, one of the company's major competitors. Since then, other high-tech companies have taken Apple's lead, rolling out logos that communicate a sense of play rather than sheer power.

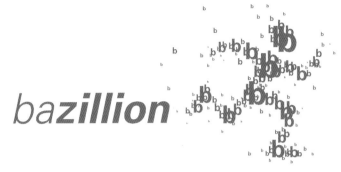

Client

Bazillion is a telecommunications company providing high-speed voice and data delivery service that combines telephone, cable, and the Internet.

ART DIRECTOR
Ray Ueno

DESIGNER
Katrin Beeck

FIRM
The Leonhardt Group

Process

When Nutel approached the Seattle-based Leonhardt Group, the telecommunications company was seeking a new name and visual identity for its high-speed voice and data delivery service. "The company was moving forward into broader markets and bigger ponds and felt limited by the name Nutel: It didn't stand out from the crowd, plus it sounded like 'noodle,'" says TLG creative director Ray Ueno. To pinpoint what kind of image the company wanted to project, the TLG team began by presenting the client with a variety of names. "We spanned the spectrum from big, scary, corporate-sounding names like 'Octacom,' which sounds like something out of the movie Terminator 2, to friendlier, more feisty names like 'Bazillion,' which has a young, dotcom-ish kind of feel," says Ueno. After the client chose Bazillion—and the message of friendliness and fun it implied—the design team turned its attention to logos. Early explorations ranged from abstract shapes to human figures to type treatments featuring computer icons in place of the A in the company's name. None of them, however, was distinctive enough and all were soon abandoned, says Ueno. Inspiration for a new direction hit when Ueno was driving to work one morning and spotted a flock of sparrows in the sky. Noticing how the individual birds moved together as a group, swarming from one point to another, Ueno thought of Bazillion's delivery system: information is chopped up into bits, bundled into little packets, shot through a cable, then reassembled on the other end so that a receiver hears a voice or sees data on his or her computer screen. Once at the office, Ueno mentioned the swarm concept to his team and they began experimenting with different ways to visually represent the idea. The result was a mass of small bs, dense in the center and growing increasingly sparse at the edges, with a larger b, for Bazillion, reversed-out in the center. Deeming it a strong direction, the team further refined the design by creating a running figure out of the swarm to add a playful touch. Lastly, a logotype, based on Univers, was added. Orange was chosen as a color to differentiate the company from the blues and reds that dominate the telecommunications category.

What Works

The logo, a running figure composed out of a swarm of lowercase bs, visually conveys the movement of millions of bits of data speeding from one place to another.

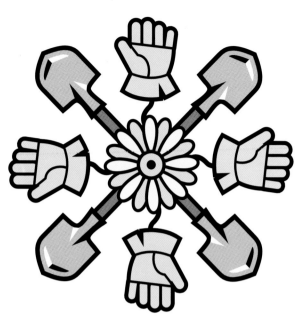

Client
Big Red Sun is a landscape architecture firm based in Austin, Texas.

DESIGNERS
Matt Hovis, Kevin Whitely

FIRM
Action Figure

Process

As landscape architects, Big Red Sun provides two services: what it calls "softscape," which entails designing gardens, and what it refers to as "hardscape," which involves developing a site so that buildings and plantings work well with each other. To reflect these two services, designers at Action Figure hoped to create a logo that would visually reference both the soft aspects of gardens and the hard aspects of construction. As a starting point, the designers sketched images of suns, daisies, tulips, gloves, and shovels, hoping one could be turned into a symbol representing landscape architecture. But the team found that although the daisies and tulips evoked the gardening side of the client's business, they were too soft to convey the company's construction services. And whereas the shovels suggested construction, they were too hard for gardening. So designer Matt Hovis experimented with different ways of combining the hard and soft elements into a single mark and came up with a radial shape, which, when viewed as a whole, suggested a sun. Next, the team added different symbols to the shape's eight spokes. One design included eight tulips, which the designers deemed too stark; another, a mixture of shovels, tulips, and gloves, was deemed too cluttered. In the end, the team opted for a design that incorporated four gloves and four shovels. Says designer Kevin Whitely, "For us, it was the best marriage of hard and soft."

What Works

The logo features a radial shape whose center is a flower and whose eight spokes are topped with alternating gloves and shovels. Its overall shape evokes a sun, which reflects the client's name, while the mark's individual elements illustrate the tools used in landscape architecture. The logo's style, reminiscent of the bold, playful look of comic books, conveys a sense of a young, vibrant company.

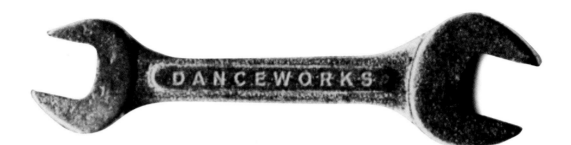

Client

Danceworks is a modern dance company, based in Austin, Texas, that incorporates technology into its choreography.

Designer
Kevin Whitely

Firm
Action Figure

Process

After changing its name from The Sharir Dance Company to Danceworks, the client needed a new logo and hoped for one that would appeal to the college-age population of its home base in Austin, Texas. To designer Kevin Whitely, that meant avoiding the clichés often found in dance logos—leaping people, for example, or dangling toe shoes—and creating something unexpected instead. So he turned away from the "Dance" part of the company's name and focused instead on "Works," concentrating on its use to describe the industrial systems in power plants or factories. To visually convey this idea, Whitely chose a wrench. As a tool, a wrench joins different elements together, a function which echoes that of a dance choreographer. As a graphic form, a wrench is easily identifiable in large sizes or small, making it suitable for a logo. Next, Whitely opted for a photographic image, rather than an illustration, so that the tool's industrial feel would not be lost. He placed a wrench directly on a scanner, entered the image into the computer, then used Photoshop to clean up its outline and add shading, highlights, and drop shadows. For the company's name, Whitely chose Akzidenz Grotesk, a typeface whose unembellished letterforms recall the straightforward lettering engraved on tools. Before adding it to the wrench, however, he modified the logotype by photocopying it multiple times to give it a worn feel that matched the mottled, nicked surface of the wrench. Of the result, Whitely says, "We didn't want to do anything frilly or soft. We were aiming for something hard, something that was the exact opposite of dance. And because there is a touch of humor to the mark, I think it appeals to young people who would never even consider spending a Friday night at a modern dance performance."

What Works

The logo, a photographic image of a wrench with the client's name set in Akzidenz Grotesk across it, serves as a visual metaphor for choreography, equating the rarefied art of creating dance movements to the down-to-earth skills of carpentry or plumbing.

littlefeet

Client

Little Feet is a wireless telecommunications company that develops and manufactures network infrastructure hardware and software.

Art Director/Designer
Denis Zimmerman

Firm
Matthews/Mark

Process

When the newly formed Little Feet came to the advertising agency Matthews/Mark, the telecommunications company was seeking a corporate identity that would somehow reflect the company's innovations in wireless technology. As a starting point, the design team at Matthews/Mark worked with the client to come up with a list of words and phrases that would describe what the company does and how it differs from competitors. From these discussions, the team developed a "brand personality," which centered around four key words: Fresh, Bold, Progressive, and Friendly. The team then began exploring logo designs. "Everything we created held up to the four brand personality words. If a design didn't speak to those four points, it got thrown out," says Matthews/Mark designer Denis Zimmerman. Of the twenty or so possible directions, a sketch that combined an image of a footprint with one of an ear was a standout due to its simplicity and playfulness, says Zimmerman. To render it, he used Illustrator to create an ear shape, basing its form on the ear icons found on computers and other electronic equipment and using a bold outline with rounded ends to give the mark a cable-like feel. Next, he added five circles for toes, and placed a logotype, based on Helvetica Neue Black Extended, below the symbol. To further emphasize the playfulness of the mark, orange was chosen as a color. Of the result, Zimmerman says: "Some people have seen a question mark in the logo, which was unintentional but which seems to work. It reflects the way the company questions the status quo."

What Works

The company takes its name from the small "footprints" of the hardware it develops. Visually, the logo reinforces this name with an image of a footprint, while at the same time referring to communication with an image of an ear.

Process

When the owners of Pumpkin Maternity came to designer Jennifer Waverek in search of a logo, they brought with them a vintage illustration of a pumpkin from an old magazine and suggested a logo based on it might work well. Waverek, however, saw two problems with a vintage-looking logo. For one, any design that was too intricate would not be flexible enough to function well across the range of applications—that a logo for a new clothing line requires; for another, a vintage design would not adequately reflect the modern, simple clothing the company offered. Instead, Waverek opted for a simple approach, a design that would be able to move from hang tags to store signage to the Web with little adjustment required. The result, created in Quark, is an oval-shaped pumpkin ("a circular one looked too much like a balloon or an apple," says Waverek) with the company's name spelled across it in all lowercase Arial. For color, Waverek chose orange and green, a combination, she says "that worked out really well because one is warm, the other is cool, so there's a nice contrast to the mark."

What Works

The company takes it name from the co-owner's nickname, "Pumpkin." The logo not only illustrates the name, but its clean, spare style echoes the simple and casual designs of the maternity wear the company offers.

Client

Pumpkin Maternity is a Manhattan-based company that designs and sells maternity wear.

DESIGNER

Jennifer Waverek

FIRM

General and Specific

edgy logos

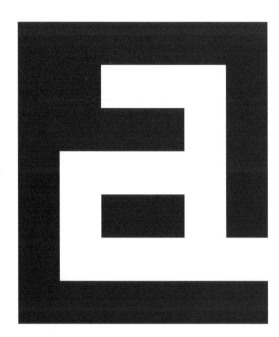

Client

aMedia is a multimedia company that publishes *A Magazine*, the largest Asian-American publication in the United States.

Art Director/Designer

Scott Stowell

Firm

Open

Process

Hoping to extend its brand into television and the Web as well as update its visual identity to reflect changes in taste, aMedia turned to the New York-based design firm Open for a new logo. In approaching the project, Open's Scott Stowell set down two parameters: the mark needed to be flexible so that it could be displayed in a range of different media and scales, and it had to be simple so that it would appeal to the many sub-groups that make up the Asian community in America. "From the beginning we were acutely aware of staying away from anything that was specific to one country because aMedia tries to appeal to all Asian Americans, whether they originally came from China, Japan, Russia, or the Indian sub-continent," says Stowell. Searching for ideas, Stowell turned to back issues of *A Magazine* and came across an editorial, written by the founding editor, which discussed how Asians are viewed in America. "The article used the well-known optical illusion of two faces with a vase between them as a metaphor for the dilemma many Asian Americans face: they are defined not by who they are, but in contrast to the mainstream culture of America," says Stowell. "The article concluded with a promise that *A Magazine* would be a place where Asian Americans are the figure, not the ground." Using this notion as a jumping off point, Stowell developed a mark where negative space was dominant. Of the result, a lowercase a carved out of a rectangular shape, Stowell says: "The viewer naturally sees the positive shapes first as being dominant, but a split-second reaction in the brain causes the negative spaces to merge together, come forward and become readable as an a. The ground has become figure and vice versa." And because the logo is based on a grid, it can be displayed at many different scales, from the very large, as in billboards, to the very small, as a magazine end slug. The symbol requires only 6 by 7 pixels to be legible.

What Works

Constructed on a grid of 6 by 7 units, the aMedia logo depicts a lowercase a reversed-out of a rectangular solid.

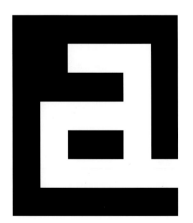

The aMedia palette consists of twelve colors, each with a lighter and darker version, as well as black, white, and a warm gray.

70 Y100 [PMS 1665]	M35 Y50 [PMS 1635]	C70 Y100 [PMS 368]	C35 Y50 [PMS 367]	C70 M100 [PMS 2593]	C35 M50 [PMS 2563]
30 Y100 [PMS 123]	M15 Y50 [PMS 120]	C30 Y100 [PMS 382]	C15 Y50 [PMS 373]	C30 M100 [PMS 247]	C15 M50 [PMS 245]
K100 [PMS process black]				M8 Y8 K22 [PMS warm gray 3]	
M100 Y70 [PMS 185]	M50 Y35 [PMS 183]	C100 Y70 [PMS 339]	C50 Y35 [PMS 338]	C100 M70 [PMS 2738]	C50 M35 [PMS 2716]
M100 Y30 [PMS 213]	M50 Y15 [PMS 211]	C100 Y30 [PMS 320]	C50 Y15 [PMS 319]	C100 M30 [PMS 293]	C50 M15 [PMS 291]

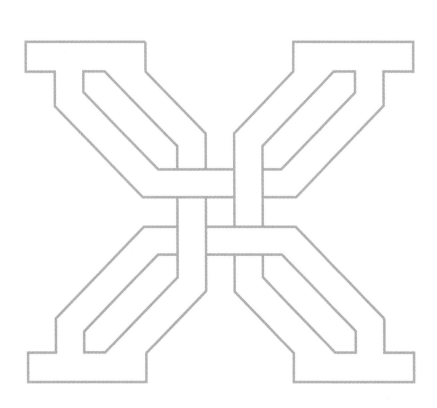

Client

Bridget De Socio is a Manhattan-based art director whose design work will be showcased in a forthcoming book entitled *X*.

Designer

Philip Kelly

Firm

pk(des)gn

Process

As a starting point, designer Philip Kelly researched the letter X. He explored the letter's formal qualities, namely, that it is symmetrical, has neither a front nor a back, and looks the same whether in capital, lowercase, reversed, or turned upside down—properties that only the letter O shares. He also explored the letter's symbolic qualities, such as its use to denote everything from a numeral ten to a kiss to a female chromosome to an unknown quantity in a mathematical equation. From these investigations a concept emerged: A design that would be bold and authoritative to underscore the letter's formal qualities, but one that was also open-ended to reflect the multiple ways the letter functions as a symbol. To meet the first criterion, Kelly emphasized the letter's symmetry, creating an X with a square at its center and exaggerated slab serifs at its tips. To meet the second, he opted for an outlined form, rather than a solid one, so that multiple shapes would arise from the negative space. Within the mark's diagonal strokes, for example, is the symbol for infinity, which evokes the seemingly endless ways an X is used. The result is a mark that visually conveys both the stability of an X's form, as well as the flexibility of an X's function as a symbol.

What Works

The logo, which will appear on the cover of the client's book, features an X constructed of interlocking geometric shapes. To reflect the content of the book, which explores the form and function of the letter X, the logo aims to elicit multiple associations. The symbol's lattice-like form, for example, calls to mind decorative patterns found in Islamic miniatures, Japanese textiles, and Gaelic typography—associations that underscore the presence of the X form across many cultures.

Statra's website features an animated sequence where logos come together to form a cube then break apart again.

Client

Statra Recordings is an independent record label specializing in electronic music.

Process

Designer Philip Kelly began the project by trying to find a way to visually represent electronic music. Because a distinguishing feature of the music is a repetitive beat in 4/4 time, he experimented with designs based on squares and cubes. Working directly on the computer in Illustrator, he constructed a cube and found that when the shape was rotated in space and its sides removed, the remaining points created an S shape, the first letter of the client's name. Further refinement led to joining the circles so they would appear to flow into each other, reflecting the fluid nature of electronic music. In choosing colors, Kelly turned to the client's name for inspiration. Statra, Kelly explains, was originally the name of a trucking business operated by the client's family in Staten Island, New York, during the 1970s. So Kelly researched New York State license plates from the 1970s and discovered their yellow and blue color worked well for the logo. For the logotype, Kelly used a typeface he had created earlier called Esosquare, a face whose square-based letterforms complement the mark's genesis from a cube.

What Works

The symbol features an abstracted S composed of seven circles that merge together as if they were fluid. The logo's space-age look reflects the futuristic music the client promotes. Its overall form, a spiral, calls to mind the spinning motion of a record turntable.

Designer
Philip Kelly

Firm
pk(des)gn

BLACKSTONE

BLACKSTONE

BLACKSTONE

Client

Blackstone is a San Francisco-based company that creates customized interoffice computer networking solutions.

Art Director
Joel Templin

Designer
Paul Howalt

Firm
Howalt Design

Process

With the Blackstone project, designer Paul Howalt faced two challenges. First, he needed to find a way to visually represent "customized computer networking." Second, he had to come up with a design that would help the client stand out in a crowded business category. To meet the first objective, Howalt focused on the word "customized" and decided to create a "customized logo," one whose basic shape would remain the same, but whose details would change from one application to another. To meet the second objective, Howalt decided to base his designs on fluid, organic shapes—rather than hard-edged, geometric ones—to emphasize the flexibility of the client's services as opposed to the standardized services provided by larger companies. Using Illustrator, Howalt experimented with monograms, basing his designs on lowercase b's, rather than the more closed and solid uppercase ones. Stretching, bending, and distorting the b's ascenders, he created three marks, each one slightly different than the other, yet sharing the same fluid-like form. For color, he selected a pale blue, a color associated with technology.

What Works

The logo, three organically shaped b's enclosed in circles, changes from one application to another, echoing the way the client's customized services change from one job to another. The mark's fluid-like forms reinforce this notion of flexibility.

Client

Cyberjack is a London-based Web hosting company.

DESIGNER

Paul Howalt

FIRM

Howalt Design

Process

Two design parameters drove the project. First, the logo's form had to be simple enough to be readable on the Web, and second, the logo's look had to suggest the high-tech industry without, both client and designer agreed, relying on over-used clichés such as swooshes or spheres. As a starting point, designer Paul Howalt created preliminary sketches of abstract shapes that he hoped would evolve into a workable design. While continuing to refine these sketches, however, he came across the typeface Dr. No, which was designed by Ian Anderson of the Designers Republic, and noticed that the font's C had the high-tech feel he was looking for. After adding subtle modifications to the letter in Illustrator so that it would work as a stand-alone symbol, Howalt enclosed it in a solid circle and added an outline. For the logotype, he chose Euphoric, a font whose rectangular-based letterforms complement the circles of the symbol. The color, says Howalt, was chosen by the client: "She happens to be the lead singer of a British rock band and orange is the color of the uniforms her band wears on stage."

What Works

The logo's symbol, a solid circle containing eight white dots, can be read in two ways: as a monogram of the company's name (the dots form the letter C) or as a visual allusion to the Web hosting services the company provides in that the cluster of dots suggests a computer jack.

Levi's	barrier-tech clothing

female brand logo male

shirts pants jackets

Client

Levi's is a 128-year-old company specializing in casual wear.

Art Director

Joel Templin

Creative Director

Brian Collins

Designer

Paul Howalt

Firm

Howalt Design

Process

For designer Paul Howalt, the project's biggest challenge was coming up with a visual language for the future, one that felt new but also familiar. For inspiration, he turned to the 1960's sci-fi cult classic *Lost in Space*, a television series about a family marooned in space, and made a series of pencil sketches based on the show's costumes. He then refined the sketches in Illustrator, transforming them into simple, streamlined marks both for stylistic reasons (to create a look that would suggest futuristic computer renderings) and for practical ones (to produce designs that would work across a wide range of applications, from hangtags to the Web).

What Works

Created for a proposed clothing line that would feature futuristic-looking pants, shirts, and jackets, the series of six logos present space-age motifs from the 1960s in the streamlined style of computer renderings. This mixture of past and present results in marks that feel both familiar and new.

yo5ho ^(Y)

yo5ho

yo5ho

yo5ho

Client

Yosho is a Web development firm based in San Mateo, California.

CREATIVE DIRECTOR

Carlos Segura

DESIGNER

Tnop Wangsillapakun

FIRM

Segura Inc.

Process

Before coming up with the final mark, designers at the Chicago-based Segura Inc. experimented with several approaches. One was based on the company's name, Yosho, which is a Japanese battle cry, and resulted in cartoon-like logos featuring Japanese super heroes. But although these marks conveyed the energy with which the client approached its work, they didn't address the company's product or industry. So the design team shifted courses, exploring designs based on communication in general and computer-based communication in particular. The resulting sketches featured computer keyboards, scroll bars, and desktop icons, designs that were strong, says Tnop Wangsillapakun, an art director on the project, but that seemed to lack the uniqueness the team was searching for. Brainstorming, Wangsillapakun typed a string of numbers into Illustrator to represent computer code then spent the day rotating and cutting them, until, he says: "It just happened. We discovered that the numbers could be transformed into letters spelling out the company's name." For the final logo, the team chose the typeface Orator, as its geometric and mechanical letterforms suggest computer code. For color, a palette of purple, blue, and green, a combination culled from computer circuitry, was selected. And as a playful finishing touch, the team replaced the customary trademark symbol, a circled R, with a circled Y, the first letter of the client's name.

What Works

The logo, which consists of the name Yosho spelled out in fragments of numbers, is a visual representation of the company's product, namely, the computer code needed to construct websites.

classic logo

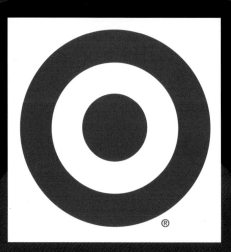

As the design curator and writer Aaron Betsky has pointed out, many of the most successful logos today are circular in form. To Betsky, one of the reasons may have to do with the ancient tradition of the mandala, a graphic device that represents the world and its forces in miniature form, much like modern logos do. The bright red Target bull's-eye is an example of the enduring power of circular marks. Though who designed it and when remains unknown, it has been in use for nearly forty years.

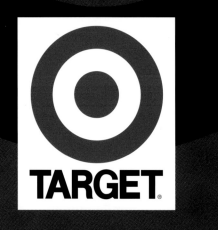

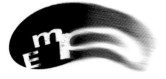

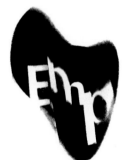

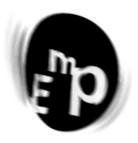

EXPERIENCE *MUSIC* PROJECT™

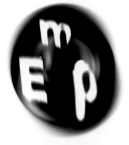

Client
The Experience Music Project (EMP) is an interactive music museum in Seattle, Washington.

Art Director/Designer
Ray Ueno

Firm
The Leonhardt Group

Process
When Paul Allen, the co-founder of Microsoft, began to develop the Experience Music Project, a music museum devoted to American jazz, R&B, and rock and roll, he commissioned the architect Frank Gehry to design a building for it that would somehow capture the fluid, ever-changing nature of music, and hired the Seattle-based consultancy The Leonhardt Group to create a similarly progressive visual identity for it. To the design team at TLG this meant creating a "kinetic" logo, one whose basic style remains consistent, but whose form constantly changes and evolves, much like a piece of music does. The result was an organic form, which calls to mind both a water drop and a guitar pick, containing the museum's initials reversed-out from black. In addition to this core mark, the team developed a series of different variations, each one distorted and stretched in a morphing program.

What Works
The logo, the museum's initials E, M, and P reversed-out from black, constantly changes form. The mark's fluidity mirrors the dynamic nature of music and reflects the endless interpretations music can invoke in listeners.

While each version of the logo has a consistent style, its variations invite viewers to decide for themselves what the EMP means.

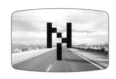

novo interactive

Digital Commerce Architects

Client

Novo Interactive is a Web design and branding firm.

Art Director
David Salanitro

Designer
Alice Chang

Photography
Oh Boy, A Design Company,
Nonstock, Inc.

Firm
Oh Boy, A Design Company

Process

As a starting point, designers at the San Francisco-based Oh Boy, A Design Company researched the client's business to find out what differentiated it from its competitors. "There are all kinds of Web design companies out there and all of them offer essentially the same set of skills and products," says David Salanitro, Oh Boy's founder and creative director. "What made Novo Interactive special was its emphasis on design. They had a notion that the computer screen had become a playground where anything could happen." To visually convey this idea, Salanitro's team opted for an evolving logo, one whose open architecture would allow for continual modification and updating. In Illustrator, Salanitro's team created a computer screen-shaped outline, then built a pixilated N and I and placed them inside the outline. Next, the team experimented with different photographic images to add as background. The images that were selected—an open road, a child's hand, a field of grass, taxi cabs, and hands clapping—are based on the five senses. Explains Salanitro: "The aim was to convey the notion that a computer is a portal into a range of real world experiences."

What Works

The logo features the pixilated letters N and I contained within a screen-shaped keyline. To reflect the interactive products the client creates, the logo's design allows for change: different photographic imagery is added to the mark depending on the application.

novo interactive

Digital Commerce Architects

novo interactive

Digital Commerce Architects

novo interactive

Digital Commerce Architects

novo interactive

Digital Commerce Architects

classic logo

Throughout the 1970s, the international shipping service was marketed under the Federal Express brand and had a logotype featuring modularly shaped letters in purple, orange, and white. However, in 1994, the company, hoping to increase the global reach of its brand, commissioned the San Francisco-based consultancy Landor Associates to redesign the logo. Led by art director Lindon Gray Leader, the design team adopted FedEx. The logo design that rose out of this name change—a string of bold, sans serif letters with an image of a forward-pointing arrow formed in the negative space between the final E and X—is today instantly recognizable and moves with ease from one language to another.

fusion.com

Client
Fusion.com is an online retailer specializing in apparel and gear for surfers, snowboarders, and skateboarders.

ART DIRECTOR/DESIGNER
Woo Andrew Roberts

FIRM
Woology

Process

For designer Woo Andrew Roberts, the biggest challenge in creating the Fusion logo was coming up with a design that was eye-catching so it would appeal to teens, yet classic so it wouldn't require constant updating. "In the beginning I didn't know what the logo should look like, but I did know what it *shouldn't* look like," says Roberts. "I wanted to get rid of anything that was overdone, like ovals and circles." So he experimented with designs based on cubes, intending to create a mark that echoed the green gift boxes used by the client. While exploring different configurations of cubes in Illustrator, he noticed that when two were placed together they formed an isometric view of the letters F and U. He then explored different treatments of the form, including a bit-mapped version which he ultimately deemed too trendy. He eventually composed the mark out of a series of solid and translucent parallelograms, a design whose simplicity would allow for animation. Lastly, he created a custom typeface for the logotype, one whose sleek, sans-serif letterforms temper the hard-edge geometry of the logo.

What Works
The logo is an isometric drawing of the letters F and U, the first two letters of the client's name. The logo's wave-like form prompts associations with various action sports, including an ocean swell and a skateboard ramp.

A print ad features the Fusion.com logo emerging from a series of cubes.

Stills from an animation sequence show the letters F and U morphing into the Fusion.com logo.

ROCKPORT

Client

Rockport Publishers is an international publishing house specializing in books about graphic design, architecture, interior design, and crafts.

ART DIRECTOR
Anita Meyer

FIRM
Plus Design

ROCKPORT
PUBLISHERS

The original Rockport logo was tied more to the physical location of the company—by the sea —than reflective of the company's product or mission.

Process

Seeking to create a unified look and feel for the many art and design books it publishes each year, Rockport Publishers worked with the Boston-based firm Plus Design to create a new brand identity. "They wanted customers to recognize Rockport as the design reference publisher who offers readers the insight needed to give their projects the necessary edge to succeed. To do that effectively meant creating something that was graphically pleasing to attract the visually oriented group of designers, architects, and artists that make up Rockport's niche consumer base, yet functional as well: Rockport's original logo, an illustration of two sailboats on the water was difficult to use. For one, the design, with its many elements and thin lines, was too detailed for use on the varying spine widths of the books Rockport published; for another, the logo's intricate rendering often competed with the books' cover art.

With these issues in mind, Anita Meyer, principal of Plus Design, set out to re-design the logo. Rather than create an entirely new one, however, she decided to rework the original sailboat logo, knowing it had built up consumer recognition over the years. The result is a design featuring two triangular shapes that suggest the sails of a boat and whose slight curves give the mark a feeling of movement that the original logo lacked. In addition, due to its streamlined form, the new mark adapts easily to a range of sizes and media. Meyer's team also created a customized sans serif typographic treatment for the company name for use in combination with the sailboat symbol or alone. Together, the two logos are flexible and interchangeable enough to apply to all Rockport's corporate identity needs as well as to the company's various product lines.

What Works

The new logo features an abstracted sailboat composed of two triangular shapes. Its simple form allows the logo to adapt easily to both print and electronic applications as well as different book spine widths. Always used in black and white, the logo conveys a sophisticated feel without being trendy.

@ http://www.rockpub.com/home.asp?page=crafts

The identity worked to brand Rockport's visual, yet diverse, product lines with new graphic spine logo and a non-traditional front-cover brand mark.

33 commercial street · gloucester, ma 01930 usa
telephone 978.282.9590 · facsimile 978.283.2742

SUSAN RAYMOND
Project Manager/Graphic Design
direct 978.282.3515 · susan@rockpub.com

The logo not only worked to give their product line visual brand identity, but also updated their corporate identity applied to the letterhead and business card materials.

directory of logo designers

Action Figure
109 East 10th
Austin, TX 78701
phone: 512.480.5900
fax: 512.480.9860

After Hours Creative
5444 East Washington Street, Suite 3
Phoenix, AZ 85034
phone: 602.275.5200
fax: 602.275.5700

Bamber Forsyth
1-5 Midford Place
London W1P 0LQ, UK
phone: 020 7969 5000
fax: 020 7387 9148
www.bamberforsyth.com

Base Design
158 Lafayette Street, 5th Floor
New York, NY 10013
phone: 212.625.9293
fax: 212.274.0876
www.basedesign.com

BC Design
157 Yesler Way, #316
Seattle, WA 98104
phone: 206.652.2494
fax: 206.749.5015

Brainstorm, Inc.
3347 Halifax
Dallas, TX 75247
phone: 214.951.7791
fax: 214.951.9060
www.brainstormdesign.com

Broom & Broom
360 Post Street, Suite 1100
San Francisco, CA 94108
phone: 415.397.4300
fax: 415.397.0670
www.broomsf.com

Chermayeff & Geismar Inc.
15 East 26 Street
New York, NY 10010
phone: 212.532.4499
fax: 212.889.6515
www.cgnyc.com

Designsite
242 West 30th Street,
 12th Floor
New York, NY 10001
phone: 212.295.9390
fax: 212.295.9390
www.designsite.net

Dinnick & Howells
298 Markham Street
Toronto, Ontario M6J 2G6
Canada
phone: 416.921.5754
fax: 416.921.0719
www.dinnickandhowells.com

Droz and Associates
209 Ninth Street, #900
Pittsburgh, PA 15222
phone: 412.338.1818
fax: 412.338.9188
www.droz.com

Eleven Inc.
445 Bush Street
San Francisco, CA 94108
phone: 415.291.1770
fax: 415. 296.1714
www.eleveninc.com

Elixir Design, Inc.
2134 Van Ness Avenue
San Francisco, CA 94109
phone: 415.834.0300
fax: 415.834.0101
www.elixirdesign.com

Enterprise IG
570 Lexington Avenue
New York, NY 10022
phone: 212.755.4200
fax: 212.755.9474
www.enterpriseig.com

Epoxy
506 Rue McGill
Montreal, Quebec
Canada
phone: 514.866.6900
fax: 514.866.6300
www.epoxy.ca

Extraprise/Tsuchiya Sloneker
Communications
140 Geary Street, #500
San Francisco, CA 94108
phone: 415.268.4500
fax: 415.268.9501
www.tscom.com

Felix Sockwell Creative
24 West 87th Street, Suite 3B
New York, NY 10024
phone: 212.579.5617
www.felixsockwell.com

Flux Labs
627 St. George's Road
Philadelphia, PA 19119
phone: 215.248.0166
fax: 215.248.0167
www.fluxlabs.com

General and Specific
285 West Broadway
phone: 212.219.9919
fax: 212.219.9989
www.generalandspecific.com

GMO/Hill, Holliday
600 Battery Street
San Francisco, CA 94111
phone: 415.617.5100
fax: 415.677.9385
www.gmosf.com

Hatmaker
63 Pleasant Street
Watertown, MA 02472
phone: 617.924.2700
fax: 617.924.0019
www.hatmaker.com

Hixo, Inc.
200 S. Congress Avenue
Austin, TX 78704
phone: 512.477.0050
fax: 512.477.3892
www.hixo.com

Hornall Anderson Design Works, Inc.
1008 Western Avenue, Suite 600
Seattle, WA 98104
phone: 206.467.5800
fax: 206.467.6411
www.hadw.com

Howalt Design
527 West Scott Avenue
Gilbert, AZ 85233
phone: 480.558.0390
fax: 480.558.0391

i.e. design, inc.
150 West 25th Street, #404
New York, NY 10001
phone: 212.255.1515
fax: 212.255.3102
www.ie-design.com

John Borruso Graphic Design
 & Collage
1243 Union Street
San Francisco, CA
phone: 415.775.9977
fax: 415.775.7977

John Smallman
922 East Lynn
Seattle, WA 98102
phone: 206.860.9988

Kevin Hall Design
87 Kenwood Road
Milford, CT 06460
phone: 203.878.0346
fax: 203.878.2112

Landor Associates
Klamath House
1001 Front Street
San Francisco, CA 94111
phone: 415.365.3869
fax: 415.365.3193
Klamath House
18 Clerkenwell Green
London ECIR OQE
United Kingdom
phone: 020.7.880.8000
fax: 020.7.880.8001
www.landor.com

Lecours Design, Inc.
3713 Highland Avenue, #4A
Manhattan Beach, CA 90266
phone: 310.546.2206
fax: 310.546.2826
www.lecoursdesign.com

Lewis Moberly
33 Gresse Street
London, WIP 2LP
United Kingdom
phone: 0207 580 9252
fax: 0207 255 1671
www.lewismoberly.com

Lodge Design Co.
9 Johnson Avenue
Indianapolis, IN
phone: 317.375.4399
fax: 317.375.4398
www.lodgedesign.com

march FIRST
410 Townsend Street
San Francisco, CA 94107
phone: 415.284.7070
www.marchfirst.com

Matthews/Mark
1111 Sixth Avenue
San Diego, CA
phone: 619.238.8500
fax: 619.238.8505
www.matthewsmark.com

Mauk Design
39 Stillman Street
San Francisco, CA 94107
phone: 415.243.9277
fax: 415.243.9273
www.maukdesign.com

Memo Productions
611 Broadway, #811
New York, NY 10012
phone: 212.388.9758
fax: 212.388.1750

Merge
884 Monroe Drive
Atlanta, GA 30308
phone: 404.724.4942
fax: 404.724.0141
www.mergedesign.com

MetaDesign
350 Pacific Avenue, 3rd Floor
San Francisco, CA 94111
phone: 415.627.0790
www.metadesign.com

Buddy Morel
3855 Inglewood Blvd., #204
Los Angeles, CA
phone: 310.313.6888
fax: 310.313.6889

Mortensen Design
416 Bush Street
Mountain View, CA 94041
phone: 650.988.0946
fax: 650.988.0926
www.mortdes.com

No. 11, Inc.
17 Little West 12th Street, Suite 302
New York, NY 10014
phone: 212.620.0177
fax: 212.620.4180
www.no11.com

Oh Boy, A Design Company
49 Geary Street, Suite 530
San Francisco, CA 94108
phone: 415.834.9063
fax: 415.84.9396
www.ohboyco.com

Open
180 Varick Street, 8th Floor
New York, NY 10014
phone: 212.645.5633
fax: 212.645.8164
www.notclosed.com

Pentagram Design, Inc.
387 Tehama Street
San Francisco, CA 94103
phone: 415.896.0499
fax: 415.896.0555
www.pentagram.com

pk(des)gn
78 Orchard Street, #3B
New York, NY 10002
phone: 212.387.9615
fax: 212.210.7474

Planet Design Company
605 Williamson Street
Madison, WI 53703
phone: 608.256.0000
fax: 608.256.1975
www.planetdesign.com

Realm Communications, Inc.
300-110 Cambie Street
Vancouver, BC V6B 2M8
Canada
phone: 604.689.3383
fax: 604.684.0819
www.realm.ca

Rick Johnson & Company
1120 Pennsylvania NE
Albuquerque, NM 87110
phone: 505.266.1100
fax: 505.262.0525
www.rjc.com

Sandstrom Design
8080 SW 3rd Avenue, Suite 610
Portland, OR 97204
phone: 503.248.9466
fax: 503.227 5035
www.sandstromdesign.com

Segura Inc.
1110 North Milwaukee Avenue
Chicago, Illinois 60622
phone: 773.862.5667
fax: 773.862.1214
www.segura-inc.com

Soapbox Design Communications
1055 Yonge Street, #209
Toronto, Ontario M4W 2L2
Canada
phone: 416.920.2099
fax: 416.920.8178
www.soapboxdesign.com

St. Aubyn
9 Desbrosses Street
New York, NY 10024
phone: 212.431.2982
fax: 212.334.3132
www.staubyn.com

t-squared design
10809 108th Avenue NE
Kirkland, WA 98033
phone: 425.822.7524
fax: 425.822.4904

The Leonhardt Group
1218 Third Avenue, Suite 620
Seattle, WA 98101
phone: 206.624.0551
fax: 206.624.0875
www.tlg.com

The Partners
Albion Courtyard
Greenhill Rents
London EC1M 6PQ
United Kingdom
phone: 44 207 608 0051
fax: 44 207 689 4643
www.thepartners.co.uk

Twelve Stars Communications
13 Chesterfield Street
London W1X 7HF
United Kingdom
phone: 44 831 801 259

Wendy Wen
53 Second Avenue, #1C
New York, NY 10003
phone: 212.353.1079

Wolff Olins
10 Regents Wharf
All Saints Street
London N1 9RL
United Kingdom
phone: 44.207.713.7733
fax: 44.207.713.0217
www.wolff-olins.com

Woology
1415 Golden Gate
San Francisco, CA 94115
phone: 415.345.8623

Y-NOT Design
10470 Spring Run Drive
Cincinnati, Ohio 45231
phone/fax: 513.825.5939

Young Associates
7120 N. 12th Street
Phoenix, AZ 85020
phone: 602.395.0011
fax: 602.395.0066
www.young-assoc.com

index